IMAGES
of America

MILAN

Martha Churchill

March 6, 2010

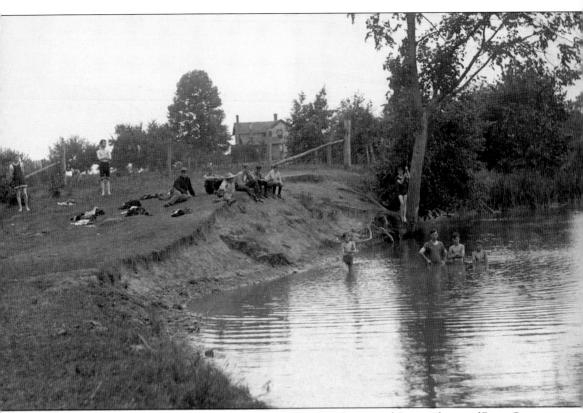

ON THE COVER: No one built this swimming hole; it just happened. Located west of River Street (now Wabash Street) south of downtown, this watering spot along the Saline River was on the edge of the millpond. In 1895, the village passed a law against public nudity between the hours of 6:00 a.m. to 9:00 p.m. Local photographer George Weller snapped this photograph in about 1900; notice the bathers are fully covered. (Courtesy of the Milan Area Historical Society.)

IMAGES
of America

MILAN

Martha A. Churchill

ARCADIA
PUBLISHING

Published by Arcadia Publishing
Charleston SC, Chicago IL, Portsmouth NH, San Francisco CA

Printed in the United States of America

Library of Congress Control Number: 2009925452

For all general information contact Arcadia Publishing at:
Telephone 843-853-2070
Fax 843-853-0044
E-mail sales@arcadiapublishing.com
For customer service and orders:
Toll-Free 1-888-313-2665

Visit us on the Internet at www.arcadiapublishing.com

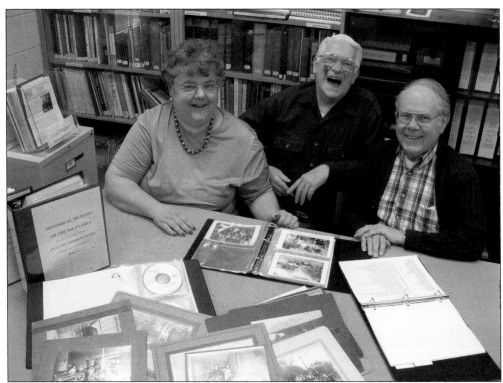

This book is dedicated to the late Warren Hale (center). He is enjoying a good joke about history with the author and Millard Phillips in 2005. Hale wrote a weekly history column from 1978 until he passed away in 2006. The author scanned the historic pictures, and Phillips placed the digital reproductions in the library. (Photograph by Kym Muckler.)

CONTENTS

ACKNOWLEDGMENTS

I would like to thank the following people and organizations for their help with the book: Linda Squires, Joyce McGovern, Alice Alstetter, Marie Tellas, Sara Ford, Dee Hale, Bonnie Jurgensen, Millard Phillips, Robert Murray, Douglas Edwards, Ray Novara, Ron Miller, Barbara Gaines, Greg Moss, Utz Schmidt, Joyce Armitage, Mary Read, Larry Read, Don Harkness, Ella Lamkin Henning, Don Kondor, Chad Nyitray, Terry R. Brinkman, Roger Olds, Luella Obsharsky, Marion Dupuis, Milan Public Library, Saline District Library, Chelsea Public Library, Bentley Historical Library, Monroe Historical Museum, Pat Harriff, Eugene Lidster of Grass Lake, editor John C. Meyer III, *Horseless Carriage Gazette*, Cora A. Webber, Karen Wheaton of Ann Arbor, Ron and Donna Cheever of Whittaker, Donna Bradberry of Moscow, Idaho, Tim Dunlap of Atlanta, Betty Goodhall, Shumla Bassitt, H. Mark Hildebrandt, Doris Jean Fulkerson, Duane A. and Isabelle Schultz, Carole Smith, Mark Smith, Joan Shaffer of Willis, Kenneth May, Robert Pratt, Kenneth Edwards of Saline, Robert Lane, Ronald R. Morey, Dave MacPherson, Warren Hale, Eugene Lidster of Grass Lake, Ron Miller of South Lyon, Roger Olds of Milan, Mike Gauntlett of Milan, Sara Ford of Milan, Doug Edwards of Milan, Gerry Weaver of Milan, Rev. Vern Campbell of Milan, Irma Ward of Milan, Paul Holcomb, and Marjorie Rooks of Northfield, Minnesota.
 Except where noted, all images are courtesy of the Milan Area Historical Society.

INTRODUCTION

The Milan area was well known to the Native Americans. When settlers arrived from New York, Connecticut, and England in the early 1830s, they found Native American trails through the area. Most of the Ojibwe, Potawatomi, and Odawa tribes left the area for reservations out west, but a few stuck around and blended into the melting pot.

One of the earliest communities was known as Wejinigan-sibi, later Paint Creek in Augusta Township. The name *Michigan* comes from the Algonquin language, meaning "big waters."

It was no accident that Milan arose on two Native American trails. One, called Plank Road, became Milan's Main Street. The other, a north-south trail, became River Street and later Wabash Street.

In 1831, John Marvin founded Milan by building a two-story log cabin where the two roads intersect, a few steps from the Saline River. This was a handy spot because he had control of a federal tollbooth, collecting money to pay for the planks in Plank Road. About the same time, William Moore founded Mooreville nearby.

The first official meeting for the London Township government was held at someone's home in 1833. The new board passed its first law: "All swine weighing less than 60 pounds each shall not be permitted to run at large, without a good and sufficient poke."

Bethuel Hack was appointed the first postmaster of Milan starting on March 27, 1833. He called the place Farmers. Then David A. Woodard, a flour mill operator, took over the postmaster job and named the town Woodard's Mills. Henry Tolan, a druggist, was next in line as postmaster, and he dubbed the town Tolanville. In 1836, the U.S. postmaster decided to name the place Milan after the township. Residents of Milan had the last laugh, pronouncing the name "MI-lan," and never mind what they say in Italy.

Residents of York Township built a Tamarack School out of logs in about 1833, but parents were afraid to send their children to school through the forest for fear of wild animals. Milan got its first school when Harmon Allen sold some land in 1853, and a log school was built at 122 East Main Street.

Then Milan was rocked by the railroads, by foundries, by a new lake, and more.

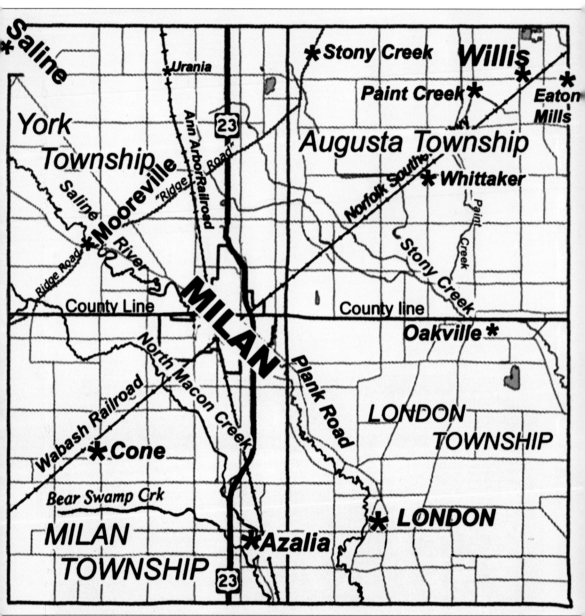

The Milan area includes two townships in Washtenaw County and two in Monroe County. Because Milan city streets are laid out on a slant, a few people own homes or businesses partly in one county and partly in the other. This map blends old and new. Vanished communities such as Paint Creek and Azalia are marked, along with two railroads built around 1880. U.S. Route 23 went through the middle of Milan until it was converted to an interstate highway in 1963; it appears on this map as it is today.

One

FARM LIFE

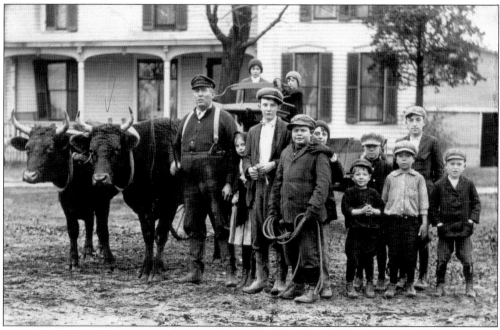

Herb Braman, owner of a Milan butcher shop, enjoys his new hobby—oxen. The first name for Milan was Farmers. Braman ordered these oxen from Chicago and picked them up at the train station around 1912. Then he brought the photographer to his home at 423 Hurd Street. His son Clayton is the boy fourth from the left holding a rope. Neighbor kids also joined in the fun. The home still stands.

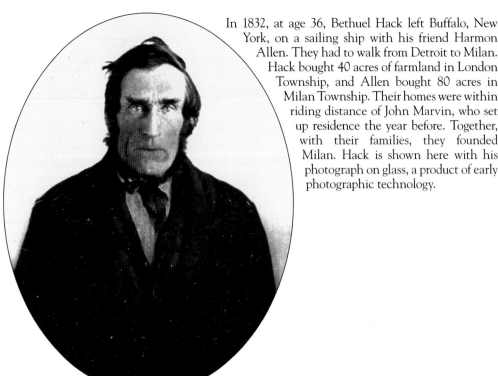

In 1832, at age 36, Bethuel Hack left Buffalo, New York, on a sailing ship with his friend Harmon Allen. They had to walk from Detroit to Milan. Hack bought 40 acres of farmland in London Township, and Allen bought 80 acres in Milan Township. Their homes were within riding distance of John Marvin, who set up residence the year before. Together, with their families, they founded Milan. Hack is shown here with his photograph on glass, a product of early photographic technology.

Sally Payne Hack, born in 1807, came to Milan with her husband and two small children. While living in a log home, she had another child. It was easy for her to receive mail since her husband was the first postmaster in Milan. At that time, he called the place Farmers. Her photograph was made on glass in an ornate box, the same as her husband's. She lived to be almost 97.

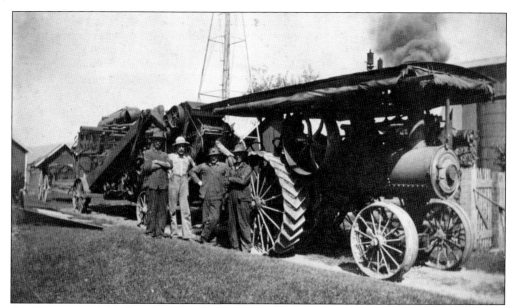

A steam-powered threshing machine was a big deal, and farmers eagerly rented or borrowed such machines to take in their harvests. Sometime between 1910 and 1920, a threshing machine was such a welcome sight at the Falk farm on Wells Road that they brought in a photographer. From left to right are Oscar Haner, Fred J. Falk, probably Joe Bentley, and Luther Clark.

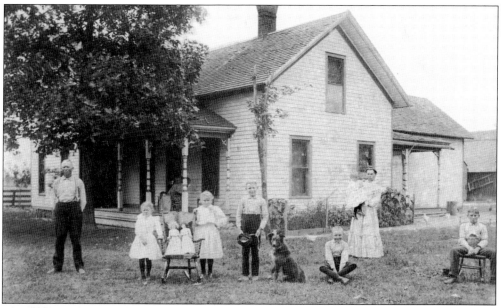

The Olds family gathers at its farmhouse at 20774 Welch Road in Milan Township about 1907. From left to right are Stephen and his children Helen with two dolls in a chair; Lena; Earl, who is holding a dog leash; Eugene sitting cross legged; baby Jessie, who is held by his mother Elisabeth (Lizzie); and George sitting on a stool. Elizabeth's sister Magdalena (Lena) Miller is in a chair on the porch. Lizzie and Lena were born Elisabeth and Magdalena Mueller. Their parents joined a wave of German immigrants to the Cone area.

John Buntz came to Michigan with his parents, Ephraim and Hannah Buntz, in 1833. The family settled in London Township along Bunce Road. John married twice, and each time his wife died. Then he married Dorcas Hurd. He had a large family, even by farmhouse standards, by welcoming stepchildren. Later in life, he Americanized his name to Bunce. His daughter Hannah Mariah married Nathan C. Putnam, Milan's first village president.

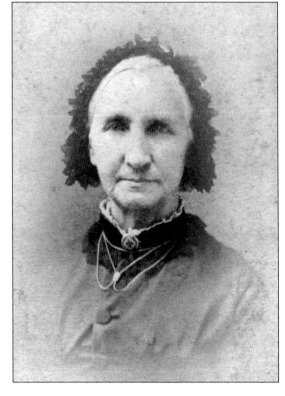

This lady was born as Dorcas Carpenter in 1815. She married Dr. Isaac Hurd in New York and then left that state so he could set up his medical practice in Milan. The doctor passed away in 1844, leaving her with five small children. A street in Milan was named after the doctor. She became the third wife of London Township farmer John Bunce. Her grandson was the legendary Walter F. Stimpson, who was famous for his scales inventions.

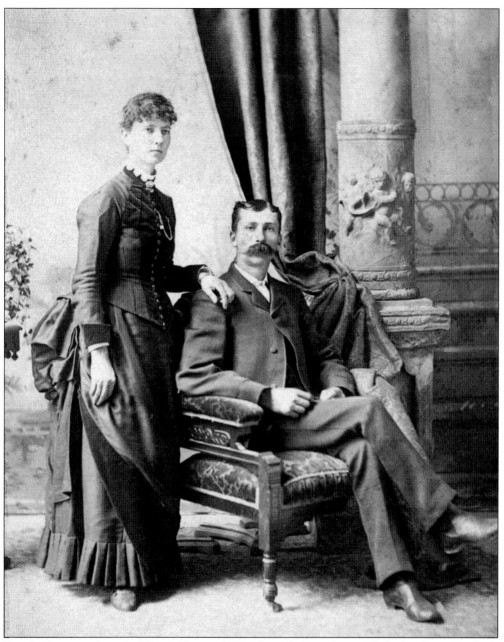

Joseph Cone was born in West Milan in 1852. His wife, Eva, shows off the bustle on the back of her dress. Joseph was the son of Erastus S. Cone and Sarah Uptegraph Cone. Erastus left his flour mill business in Vermont in 1831 and headed to Milan Township with his pregnant wife Nancy and five children. It was unusual to divorce at that time, but Erastus divorced his first wife and married Sarah, a West Milan neighbor who had just turned 17. Altogether Erastus had 17 children; Joseph was the ninth. No wonder the Wabash Railroad named the West Milan train station Cone.

Josiah Fuller Dexter was born north of Milan in 1852. His father, Joseph Dexter, was one of the four Dexter brothers who came to Milan from England and bought farms along Dexter Road. Today part of Dexter Road is known as Carpenter Road. Josiah is shown here with his wife, Rhonda R. Throop. He operated a blacksmith shop in Milan. In 1888, he was named one of four constables for the village.

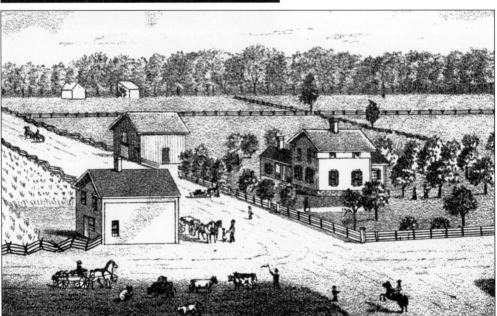

The home of William Ostrander is shown just west of Plank Road in 1876. He was born in New York and came to London Township when he was 27. He met Sally Hack, daughter of local farmer Bethuel Hack, and quickly married her. His house served as a general store and post office. His six children attended school across the street, as shown in this illustration from an atlas. Ostrander also farmed more than 100 acres and took a turn as township supervisor.

Nathan Calvin Stuart was one of the first farmers to settle in London Township from "back east." He was only 17 when he arrived in 1835. He was married three times, and altogether he had 11 children. Stuart served as London Township supervisor, justice of the peace, coroner, and in other civic positions over the years.

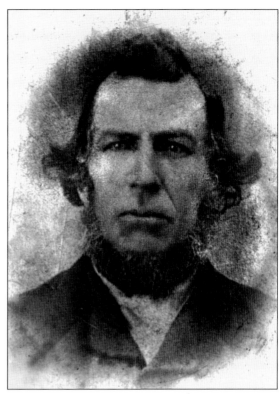

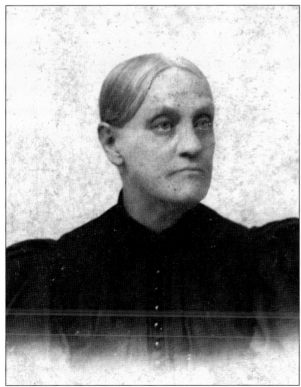

Jeanette "Rachel" Young became the third wife of Nathan Stuart, raising eight children on their farm in rural London Township. She was born in 1830 in York Township. Rachel led a difficult life, but in 1898 when she visited a photographer, she looked pretty good.

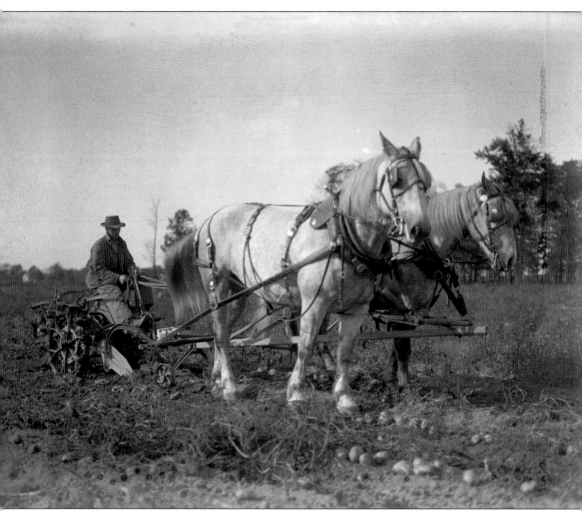

A farmer near Paint Creek in Augusta Township takes in his potato crop. The mechanical potato digger features a spade in front, digging about 8 inches and pulling up the potatoes. In many parts of Augusta Township, the sandy soil is ideal for vegetables. The photograph was saved on a glass plate about 1910. A home hobbyist in the area owned one of those new dry plate cameras. (Bentley Historical Library, H. Mark Hildebrandt collection, hs4422.)

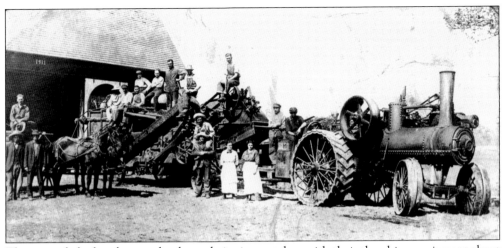

These people look to be proud to have their picture taken with their threshing equipment about 1915. Some of the equipment runs on steam, and some of it is horse drawn. Powerful equipment like this saves many weeks of backbreaking work for the family and hired help.

The cheese factory in Paint Creek was doing so well in 1874 that it purchased this advertisement in the Washtenaw County atlas. The drawing shows a good-sized facility, and two horse-drawn wagons are loaded with milk. Some men stand around outside looking important. The cheese factory had to be close to dairy farms. Paint Creek was once a thriving community in northeastern Augusta Township.

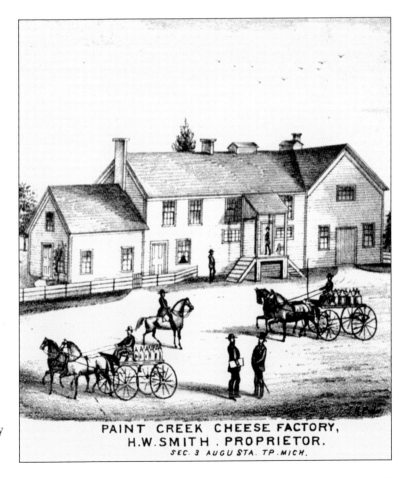

PAINT CREEK CHEESE FACTORY,
H.W. SMITH . PROPRIETOR.
SEC. 3 AUGUSTA. TP. MICH.

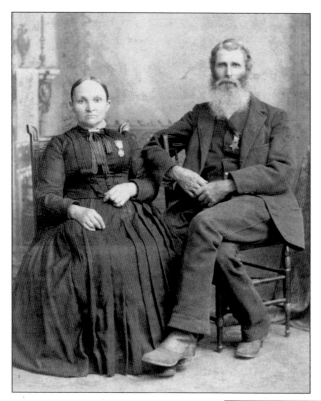

John Pool was born near Chelsea and came to a farm in London Township in 1832 when he was one year old. He took over his parents' farm between Hitchingham and Townsend Roads. He took Mary Kidder as his bride and they had five children, two of them living to adulthood. He was proud to serve in the Union army, showing off his Grand Army of the Republic (GAR) badge on his vest. His wife wears her badge for the Women's Relief Corps, basically the GAR auxiliary.

Florence Rice Miller, born in 1858, holds her daughter Nellie around 1905. The Rice family arrived in Milan Township around 1833 when Caleb Rice of New York purchased 250 acres for $300. His son Josephus Rice donated 2 acres for the Rice Cemetery. Nellie's father was born Georg Heinrich Mueller, but he went by "Miller." His family came from Bavaria, Germany. He was probably busy running the farm when his wife visited the photography studio.

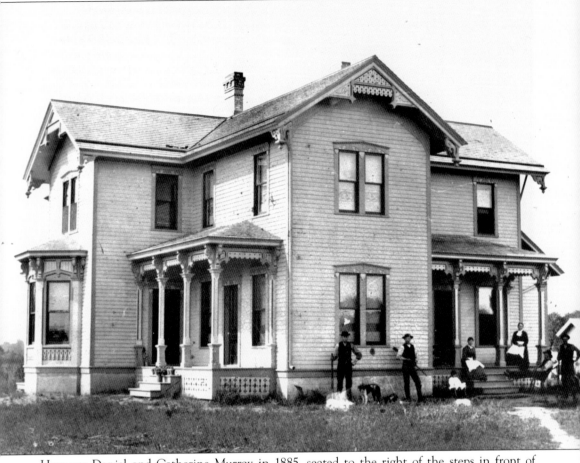

Here are Daniel and Catherine Murray in 1885, seated to the right of the steps in front of their York Township residence. They needed a large house to raise their eight children plus a granddaughter, seated near the steps. This Victorian home was built on the northwest corner of County Street and Sanford Road. The house is gone now; a party store stands there.

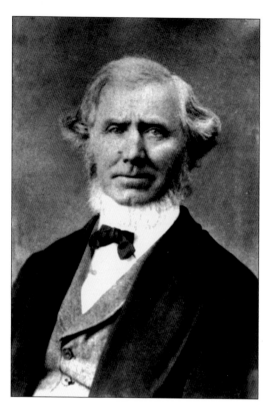

William Dexter and his three brothers were just teenagers in 1830 when they crossed the ocean from England with their parents. Soon after arriving in New York state, the parents died. In 1832, three of the brothers joined another family, traveling to Michigan on the Erie Canal. The Dexters and Fullers populated many of the farms north of Milan, so the north-south road into Milan became known at that time as Dexter Road.

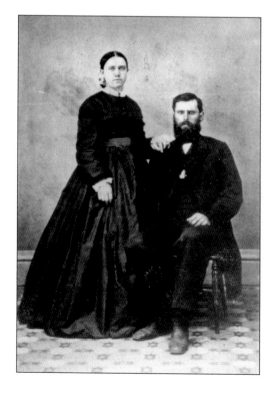

Othniel E. Gooding married Lucy Dexter in 1866. Her father, William Dexter, was one of the original Dexter brothers to settle on farms north of Milan. The Goodings had six sons and one daughter on their York Township farm. Based on the dress and hairstyles, this photograph could have been made soon after their marriage.

Two

BUSINESS AND INDUSTRY

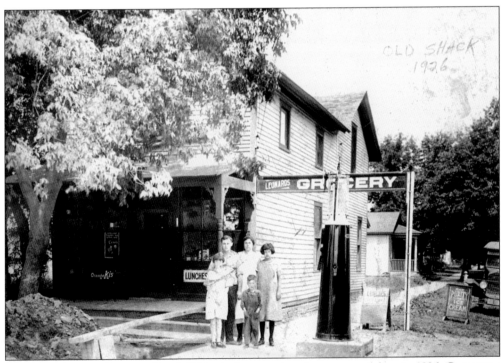

Leonard's Grocery Store on South Wabash Street enjoyed some remodeling in 1926. Customers came from the neighborhood or from the train station across the street. Willis and Mary Leonard stand next to their daughters Luva (left) and Alice; the boy, Clyde Mitchell, was from the neighborhood. A gasoline pump stands next to them under the sign. This building is still there but looks different as the Old Shack bar.

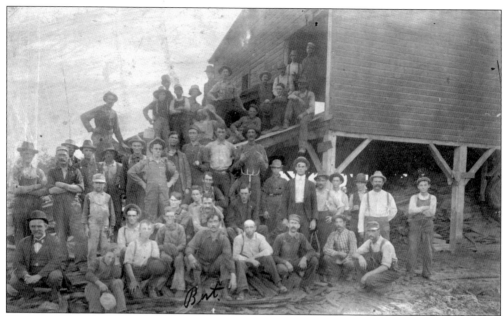

The Milan Barrel and Hoop Mill hired plenty of workers in about 1900, as shown by this group photograph. This could have been the barrel manufacturer on West Main Street by the railroad tracks. It is possible another barrel maker was located on Redman Road. One man, Albert Allison of London Township, is identified in this photograph. He is in the front at center, with the name "Bert" written in ink at his feet.

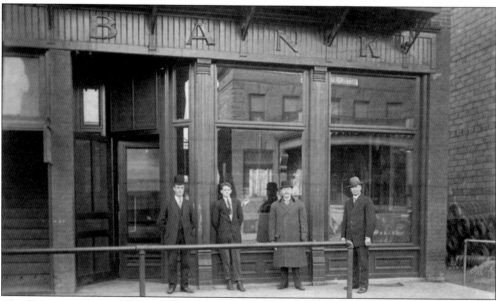

The Farmers and Merchants Bank was the first bank in Milan, established in 1882. Some bank executives hired a photographer around 1910, probably to show off their new location. The Stimpson Hotel across the street is reflected in the windows. William Whitmarsh, the president of the bank, may be one of these four gentlemen. The Independent Order of Odd Fellows (IOOF) built this three-story structure and rented the first floor to the bank. The IOOF had a dance hall upstairs.

Oakville was a major town in the area when Howard's Store ran this advertisement in the *Milan Sun*. The date was February 18, 1882, and he was ready to sell groceries, dry goods, boots, shoes, and meat. This store sold nearly anything that a person could legally purchase. Oakville had a commercial area on the northern edge of London Township, but it never received a railroad and thus died out.

Howard's Store,

OAKVILLE,

Is supplied with a large stock of

Dry Goods, Groceries,

Boots, Shoes, &c.

Keep all kinds of Fish, Pork and Lard. Conntry Produce

Bought at highest market price. Pay in either cash or goods. You can buy GROCERIES and DRY GOODS for LESS MONEY at HOWARD'S STORE than at any other store in the county.

Frank M. Miller was born in Stony Creek northeast of Milan in 1871. While in his 20s, he learned the drugstore trade by experience. In 1900, he opened a drugstore in Milan that remained open as a drugstore, under various owners, for more than a century. He joined the Masonic temple and the Knights of Pythias. He served on the school board and the village council. Miller's Drugs was a household name in the Milan area for many generations. He lived until 1938.

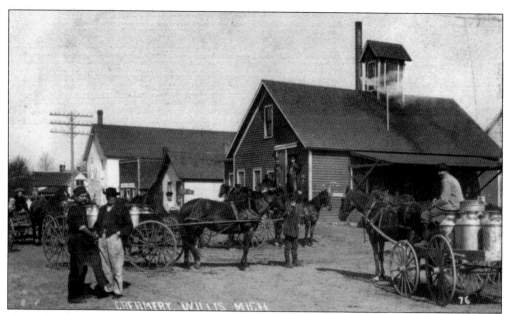

Once the Wabash Railroad came through Augusta Township with a station at Willis, this creamery became possible. Dairy farmers depended on a nearby local creamery to deliver their product each morning. The creamery depended on the train to transport the ice cream, butter, and so forth to grocery stores. Willis was named after Willis Potter. He helped provide the train station that created the town.

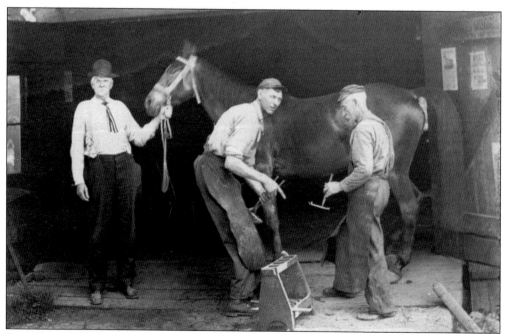

Some farmers had their own blacksmith tools and knew how to shoe a horse. Others took their horses to a professional. Here William Gauntlett, 61, of Mooreville holds his horse steady at a blacksmith shop around 1910. The shop was on the end of Tolan Street and around the corner to First Street. Walter Bortles (center) wears a leather apron, and Mr. Steffe stands on the right.

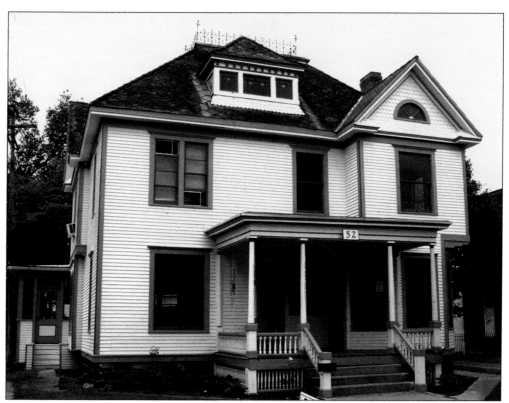

Sometime before 1881, Dr. Henry B. Bessac probably built this gorgeous Victorian home still standing at 52 East Main Street. He applied the classic medical floor plan, with the door to his home in the center and a door on the side leading into a separate medical office and hospital. A first-class brick carriage house in the back is also still standing.

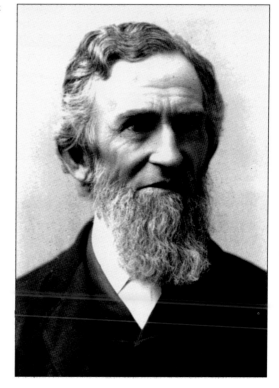

Bessac worked hard to make Milan a village. In 1886, he took over for a year as the second village president. Bessac was born in Manchester in 1845, about 22 miles west of Milan. He graduated from the University of Michigan Medical School in 1873 and came to Milan with his wife, Julia, and their growing family. He had a brick building constructed at 13 East Main Street in 1884, renting the downstairs to the post office and using the upstairs for a medical clinic.

Emmett F. Pyle, M.D., came to Milan with his wife, Etta, in 1882. A graduate of Buffalo Medical University, Pyle was 36 years old. He and Etta lived in a redbrick house on the northeast corner of Ferman and East Main Streets. He used half the building for his medical office and the other half for a residence. He was elected president of the village board in 1887. Later he either built the Victorian house at 52 East Main Street, or he bought it from Dr. Henry B. Bessac.

William R. Calhoun and his wife, Emma Fuller, are seen here in what is probably a wedding picture taken about 1890. He served as a dentist in Milan, taking over the Victorian home on East Main Street from Pyle. With two entrances, the home worked well as both a residence and dental clinic. After Calhoun died in 1939, Emma stayed in the home another 25 years.

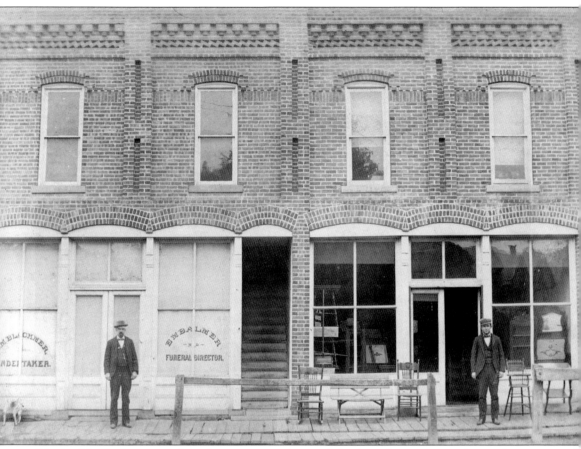

Charles M. Blackmer stayed in the grocery or dry goods business in a store on the southeast corner of downtown Milan until 1885, when he set up his undertaking business. He is pictured at 102 East Main Street at the funeral parlor with his son Eddie on the right at the furniture store. It was customary for undertakers to sell furniture, since a coffin was a type of furniture. Samples of the merchandise are seen on the sidewalk to entice customers. This photograph was taken around 1890.

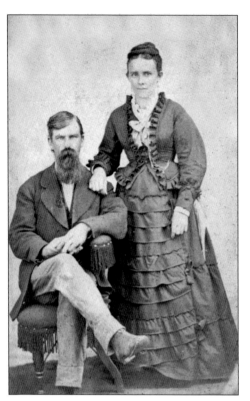

Charles and Emily Blackmer made a lovely couple while their first few babies came along. This portrait might have been taken around 1868, as their family was moving from Saline to a farm north of Milan. They had 10 children altogether, with eight of them living to adulthood.

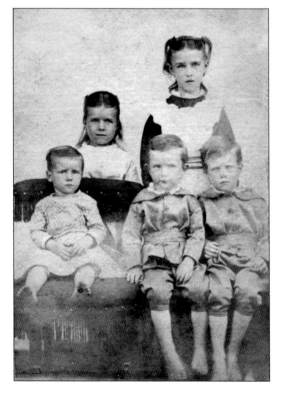

Tired of cleaning up the children and putting their shoes on, the Blackmers took their brood to the photography studio and let nature take its course. Pictured from left to right are (first row) Webb, Thurlow, and Eddie; (second row) Grace and Cynthia. Since Webb looks like he is about two, the photograph date is about 1874. Around that time, Charles was supporting the family by farming in York Township.

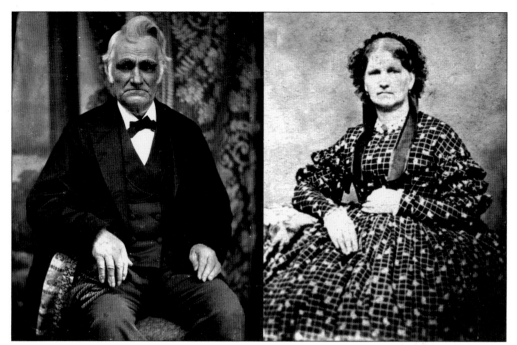

David Blackmer had to grow up fast. Born in 1803 in Massachusetts, he had to learn the shoemaker's trade by age 15 because his father had died. He married Zevia Parmenter when he was 23 and brought the family to Michigan in 1856. In 1885, he spent $1,000 on a bell for the new Milan Baptist Church. He died in May 1888. Zeviah was born in Massachusetts in 1805 and married Blackmer "out east" before having four children, including Charles. She died in 1871.

Sears Thurlow Blackmer really enjoyed clothing. Here he is shown with one glove on, one glove off, and a fancy top hat. He sold clothing on his own, and then he went into partnership with George Minto. They sold men's clothing in a new building on East Main Street in the center of downtown.

George Minto grew up in Shiawasee County, but he settled down quickly in Milan when he set up a men's clothing store in downtown Milan with Sears Thurlow Blackmer, his brother-in-law. The old Babcock Hotel was hauled away from the northeast corner in 1896, and Minto built his new brick retail store there.

Mate Minto was married to a clothing retailer, so she knew how to dress up. Blackmer, her husband, started out selling clothes from his father's former grocery store in the center of downtown Milan. This apparently went well, as he soon formed a partnership with Mate's older brother George to sell men's clothing across the street.

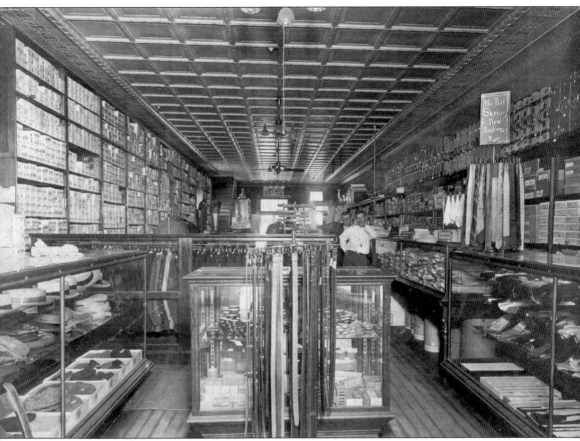

This is inside the Blackmer and Minto men's clothing store around 1900. Ernest Luxton (left) and Harry Harmon await customers. Belts and hats are in the front. In the middle, a glass display case holds a huge supply of shoe polish canisters. The store is stocked up with luggage, shoes, suit jackets, and shirts all out on display. A staircase in the back leads to the second floor. The store still stands at 3 East Main Street, but it is remodeled inside.

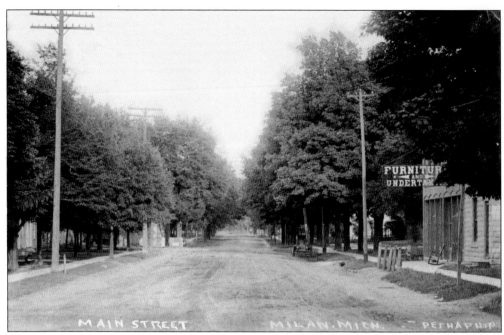

Charles M. Blackmer made a good living selling furniture and serving as the town's undertaker. This 1910 photograph shows his business at 112 East Main Street, a handy location next door to his home. This building still stands. Also shown on the far right is the beginning of a fruit and candy store being built by George Bassett, a native of Lebanon. The fruit store still stands at 108 East Main Street and is owned by the author. (Photograph by Frank Pesha.)

In 1915, Bassett arrived in Milan with his wife, Wasiela, and their growing family. He set up a fruit and candy store at 108 East Main Street. In 1920, his younger cousin, George E. Bassett, had a family portrait done. The cousin was living in a Lebanese neighborhood in St. Albans, West Virginia, at the time. He is shown with his wife, Sadie, and daughter Edna. George and Sadie opened a variety store on East Main Street at Ferman Street.

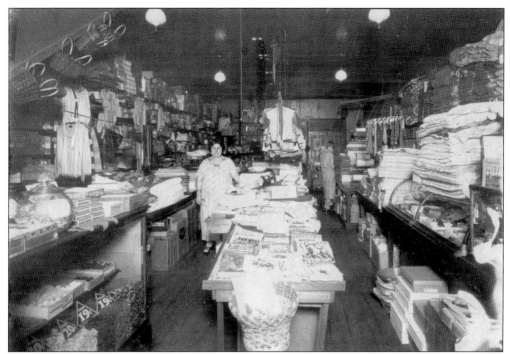

The older George Bassett ran a fruit store and confectionery at 108 East Main Street, living next door with his wife, four children, and some other relatives who arrived from Lebanon. The younger cousin George E. Bassett and his wife, Sadie, set up a variety store across the road at 49 East Main Street. Sadie is pictured standing proudly next to her merchandise, including just about everything from candy to magazines and baskets.

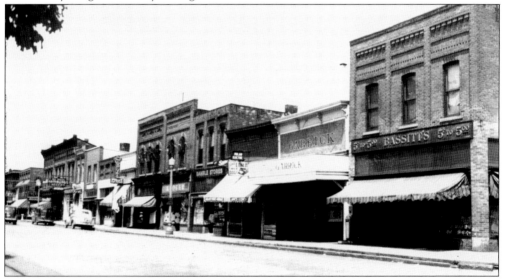

George E. and Sadie Bassett decided to spell the store name "Bassitt." Their children Edna and Eli were given the last name Bassitt. By the 1940s, the Bassitt's store was entrenched in downtown Milan as the place to go. Over the years, Eli and his wife, Shumla, took over the business from his parents and emphasized high-end merchandise. Eli was elected mayor in 1978. Shumla earned a reputation for civic projects.

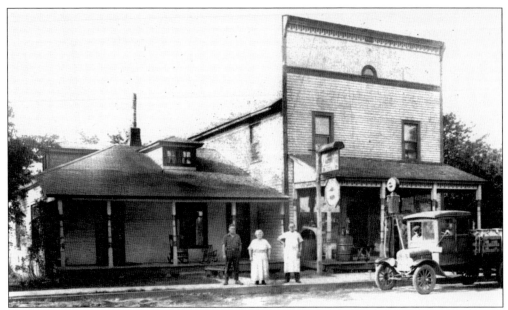

One of the first businesses in Willis was the pickle factory next to the railroad. Later the factory was converted into a grocery store, shown here in 1913. The owner, George Howell, is on the right wearing a white apron. His wife, Edith, is in the middle, and their son Gale Adrian Howell stands on the left in darker clothing. A gasoline pump stands near the store's entrance, ready to fill the tank of any motorcar. Later the place was known as the Pickle Barrel restaurant.

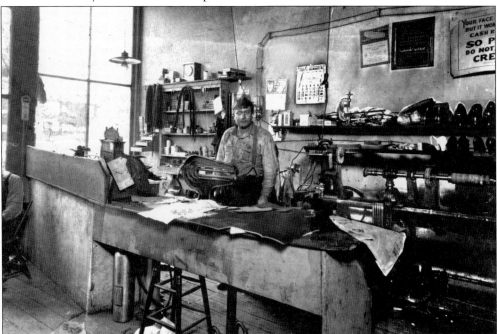

Emory Compau owned quite a collection of gadgets to sew leather for shoes, gloves, and even the occasional horse harness. His shop was on the north side of East Main Street near Ferman Street. A sign advertises Goodyear wingfoot heels. The calendar behind him shows the date as May 1932.

In 1895, William Whitmarsh was elected president of the Farmers and Merchants Bank of Milan. That same year, he was elected president of the Village of Milan. Daraxa (Draxy) Dexter was one of 11 children. Her father came to Milan in 1832 with his brothers. Dexter married Whitmarsh and apparently convinced him to set up his grocery store in Milan. Dexter was born in 1845, so if she is 20 in this tintype photograph, it was taken in 1865.

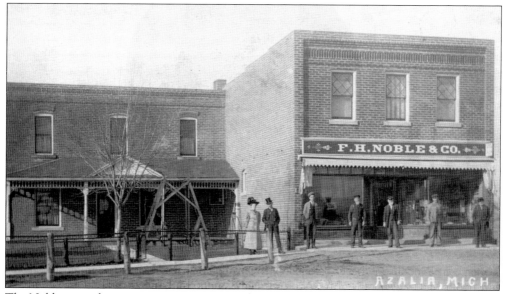

The Noble general store was a mainstay in Azalia and could have sold this postcard featuring its own business. The building on the left is a residence. With a brickworks in Azalia, it was more common for people to build with bricks, including homes. The main highway to Toledo, Ohio, U.S. Route 23, went through Azalia's downtown at this time, making it a hot spot in the area.

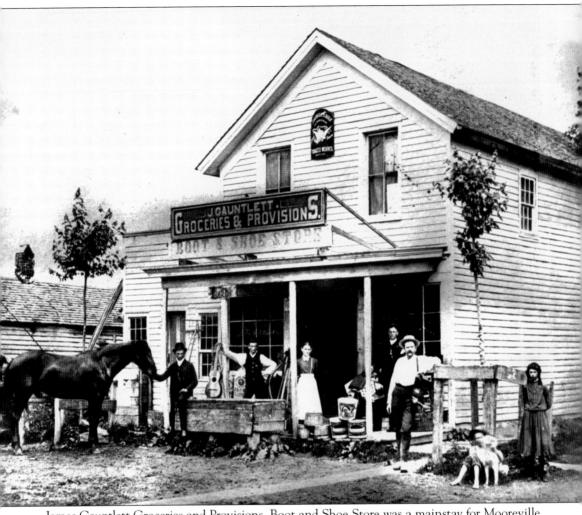

James Gauntlett Groceries and Provisions, Boot and Shoe Store was a mainstay for Mooreville residents in the late 1800s. It stood on the northwest corner of Stony Creek and Mooreville Roads. Buckets marked "candy" sit on the front porch. From left to right are Elon D. Gauntlett holding a horse; his brother James W. Gauntlett with a guitar; his mother Charlotte; his brother John C. in dark clothes; and their father James Gauntlett out front. Children are unidentified.

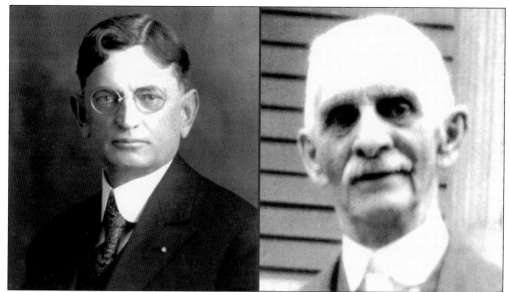

Charles Gauntlett (right) was born August 7, 1853, on the family farm west of Milan. He worked as an apprentice to an older brother, learning the shoe business, and then he opened a shoe store in Milan. In 1876, he married Jennie Bunce. He served as Milan village president for two years, beginning in 1903. Elon D. Gauntlett (left) was born in 1867 and started a variety of Milan businesses. He married Nellie Dickenson in 1887, according to his family bible, and had one child. His second wife, Addie Van Wormer, was a schoolteacher.

Sarah Pool Gauntlett (left) is pictured in front of her rooming and boardinghouse on West Main Street about 1918. Her friend Winona Campbell stands nearby. A Ford dealership touches the house on the west, built by Elon D. Gauntlett originally to sell Reo automobiles. Sarah's husband, Archie, was Elon's uncle. This house was moved back towards the Saline River in 1939 to make room for William H. Storl's new movie theater.

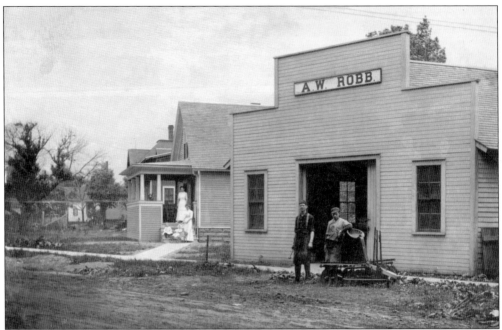

Alex W. Robb stands outside his blacksmith shop next to his helper, Arley Farley (right, in light shirt). His shop was located just east of the village fire barn, where County and East Main Streets come together. He built his shop and house around 1910 when he came to Milan. Robb's wife, Ida Belle, is standing with their son Richard and baby Judson in the baby buggy; the woman on the top step is Ida's sister Gertrude Brown. The Robb family came from Scotland.

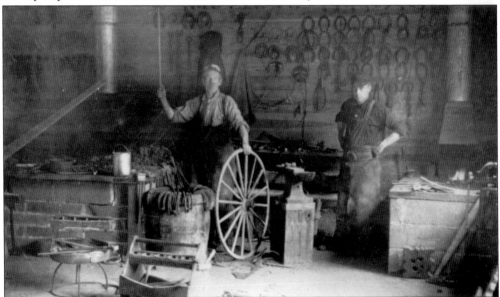

The year was 1915, and gasoline automobiles were starting to take over for horse-drawn buggies. Even so, Milan blacksmith Alex W. Robb (left) continued to serve farms and other horse owners in the region whenever horseshoes were required. The number of blacksmith shops in the area slowly declined, but Robb kept his earnings up by opening a gasoline station on the County Street side of his shop.

In September 1861, Nathan C. Putnam left his family farm in London Township. He had his portrait taken in uniform as he joined the Union army at age 19. Putnam was almost killed when the horse he was riding fell and rolled over him. After six months in a military hospital, he was discharged back home to Milan at the height of five feet six inches—three inches shorter than when he entered the military.

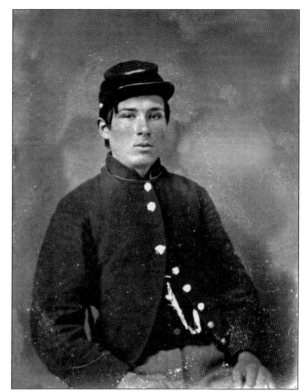

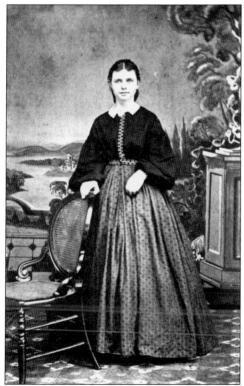

Hannah Mariah Bunce, born in 1843, probably had this picture taken close to 1860. She is hanging onto a chair for a reason. It took time to expose a photograph, and the slightest movement would result in a fuzzy picture. She was raised on a farm in London Township and married her neighbor Nathan C. Putnam, another London Township farmer. They tried to farm until 1876, when her husband's war injuries got the better of him. Then they moved into town and set up a department store.

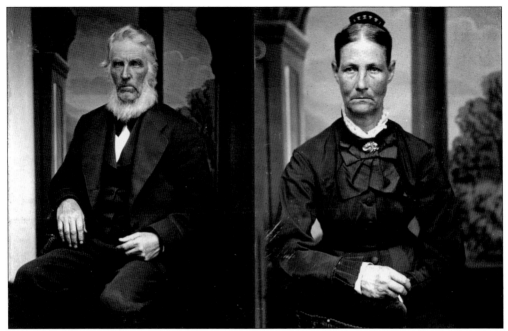

John C. Putnam, father of Nathan C. Putnam, was a tough old farmer. He survived an injury to his mouth when he was attacked by a bull. He brought his family to the Erie Canal in New York around 1855. His wife died two years later. In 1858, he moved near Milan and married his second wife, Mary Frasier, in 1859. Her tintype photograph, seen here, was probably taken the same time as her husband's.

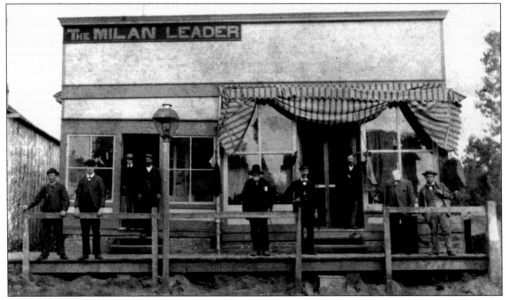

Albert B. Smith stands in the doorway under the *Milan Leader* sign. He is on the right side of the door, celebrating the opening of the weekly paper at his print shop on River Street. His partner, Alfred E. Putnam, is the tall man in front, second from left. The year was 1881, and Putnam was just 14 years old. His father, Nathan C. Putnam, leans on the doorway of his dry goods shop next door. The elder Putnam took office as Milan's first village president in 1885.

Four up-and-coming businessmen in downtown Milan strut their stuff at a photography studio. This tintype was made around 1880. From left to right are Frank Hill, Alfred E. Putnam, Nicholas Allison (sideways), and Albert B. Smith. These men glued themselves together through marriage. All of them married sisters from the McNeill family, except Hill, who married Alfred E. Putnam's sister. Alfred built a dry goods store on Wabash Street and invented a scale to measure the length of fabric.

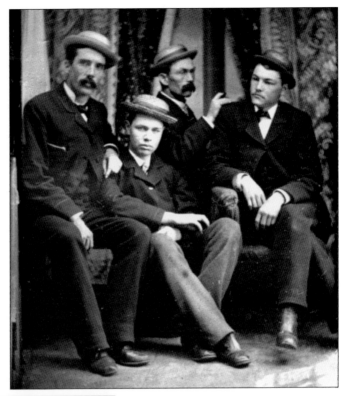

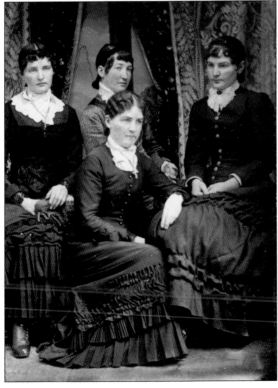

The McNeill sisters of Petersburg, south of Milan, are pictured here around 1879. Three of these lovely ladies married Milan businessmen, perhaps because their father was a contractor with connections in Milan. Pictured from left to right are (front) Elmina (Mina) McNeill Smith; (second row) Alice McNeill Putnam, Mata McNeill Skillen, and Frances (Fanny) McNeill Allison. All four ladies were given pink touch-ups on their cheeks over the tintype.

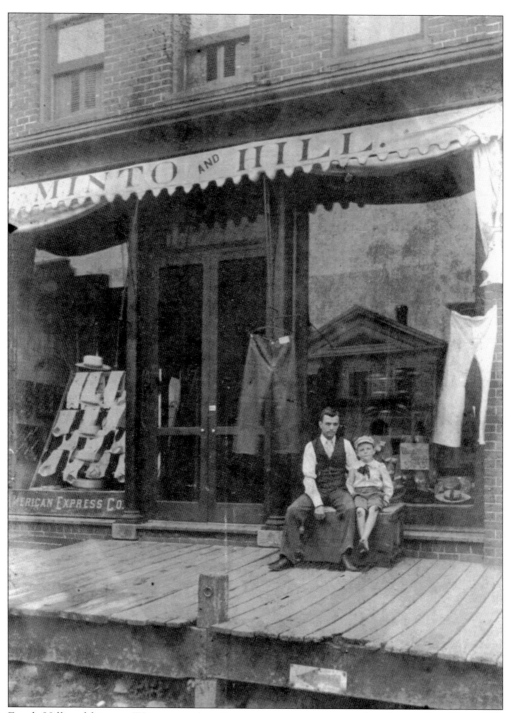

Frank Hill and his son Winton catch a few moments together on the plank sidewalk outside Minto and Hill men's clothing store at 3 East Main Street around 1903. Men's pants are being featured. The billiards parlor across the street is reflected in the glass window above their heads. George Minto partnered with Hill for a short time, in between partnerships with brothers-in-law. Hill's late wife, the former Alice Putnam, was the daughter of Milan's first village president.

Gleaming with medals earned in the Masonic ritual, Orrin A. Kelley was a natural choice for Milan village president in 1893. He owned quite a bit of stock in the Farmers and Merchants Bank, and he built several brick storefronts on West Main Street. One of those shops, at 9 West Main Street, was home to his hardware business. He sold stoves, tinware, pumps, windmills, farm implements, paints, and oils. He lived until 1924, when he was 74.

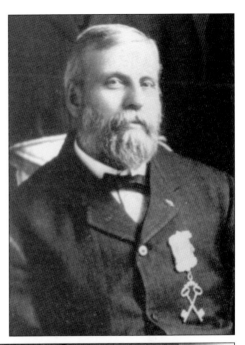

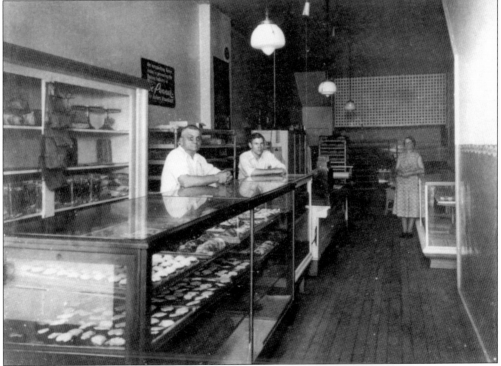

Here is the Milan Bakery about 1927. Norman Eighme, pronounced "amy," stands behind the counter next to a young employee. His wife, Ada, stands further back. This store was located at 38 East Main Street in the Palmer block. Just east of there, at the end of the block, Eighme had another storefront devoted to bread production. He sent out truckloads of fresh bread to stores and homes.

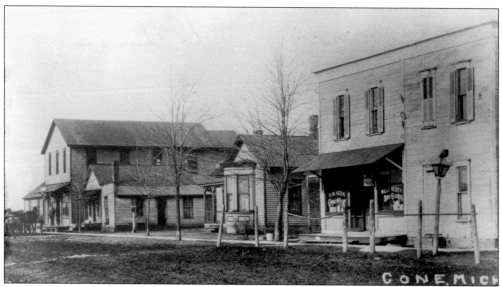

Cone was a hopping place around 1907. The store on the right has a sign that says "Millinery, Dry Goods" in one window and "G. W. Auten Groceries" in the other. A sign above the door indicates a public telephone is available. The Wabash Railroad came through West Milan in 1880 and set up a train station called Cone. West Milan changed its name to Cone, and the community blossomed.

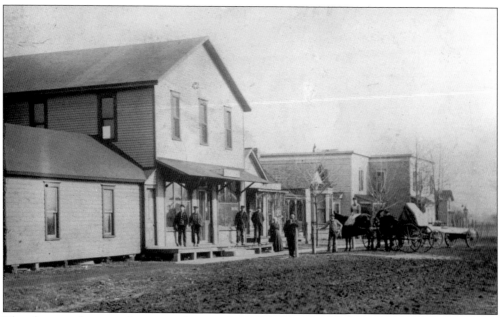

The photographer was almost standing on the railroad tracks to take this shot of the Allshouse and Raymond General Store in Cone in 1907. A second floor above the store provided space for a dance hall. The residence of Edward Allshouse peeks out to the right. Some gentlemen who appear to wear railroad uniforms are standing in front.

44

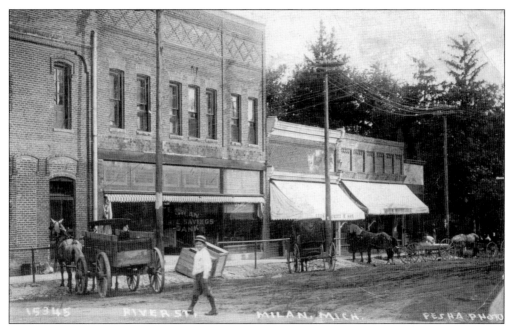

The Milan State Savings Bank was organized on December 2, 1910. It opened for business on the east side of River Street (now Wabash Street) exactly two months later. This photograph was probably taken soon after the bank opened. The bank building originally housed Alfred E. Putnam's dry goods store. (Photograph by Frank Pesha.)

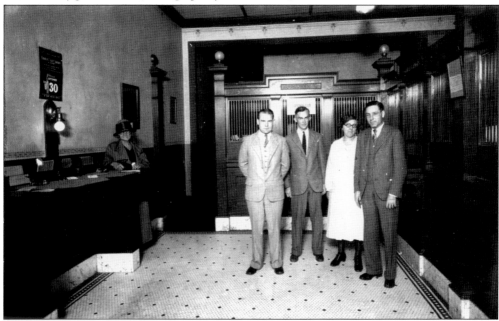

An older lady stops to watch as executives of the Milan State Savings Bank have their photograph taken. A calendar on the wall states that it is Friday, September 30, 1927. The bank executives, from left to right, are Gerald Allen, unidentified, Beulah Richards, and Grant Laskey. This bank was established on the east side of Wabash Street on December 2, 1910, and it is still in business today thanks to some corporate changeovers.

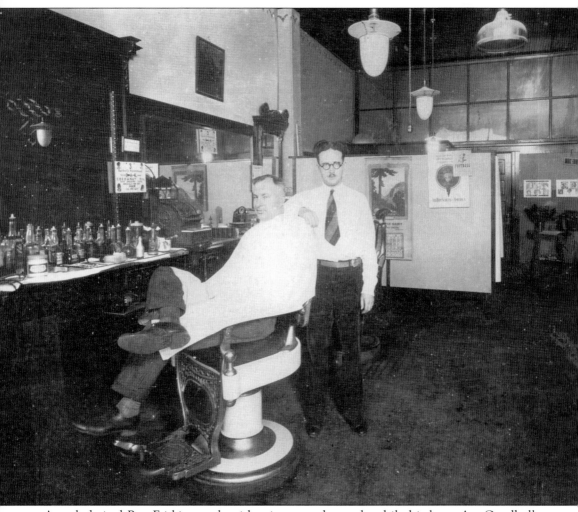

A curly haired Ray Frisbie stands with scissors at the ready while his boss, Art Goodhall, waits for a haircut in 1927. It is hard to believe a barbershop would need that many bottles of salves, gels, creams, and lotions. This barbershop was situated on the south side of the bank on Wabash Street.

Wila P. Lamkin was born in Raisinville, south of Milan, in 1861. His father, Benjamin Lamkin, moved to Milan around 1887 to set up a foundry in addition to a blacksmith shop. It was Milan's first foundry. Wila ran a variety of industries in Milan, including the town's first electric-generating plant, a flour mill, a cement distributor, and a creamery. He did saw gumming, wood turning, and sold lunches at parades. A street was named after him.

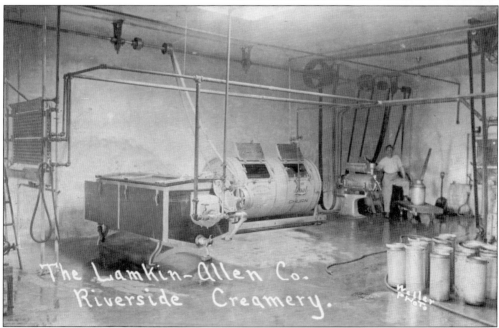

Wila P. Lamkin presided over an astonishing array of businesses in Milan. Apparently he was part owner of the Lamkin Allen Riverside Creamery, shown here around 1908. A small town like Milan could have several creameries to handle all the milk produced in the surrounding countryside. The creamery would hire deliverymen to take dairy products to the farms. Some even sold ice cream. (Photograph by George Weller.)

Wila P. Lamkin's electric-generating plant is seen on the west side of Wabash Street in about 1900. A colossal smokestack is visible on the left side of the building. The plant was powered by coal-fired steam generators. Wires crossing the front of the building powered Milan's streetlights. This building is gone, replaced by the American Legion.

Wila P. Lamkin had talent as a business promoter. His father, Benjamin Lamkin, started the first foundry in Milan, and Wila apparently kept it going with success. His advertisement in the *Milan Leader* from January 4, 1889, mentions wood turning, saw gumming, and plow repairs. Basically he did anything with wood or metal. His address states River Street, which was later named Wabash Street. Photographs show his business concerns on the west side of the street one or two doors south of Main Street.

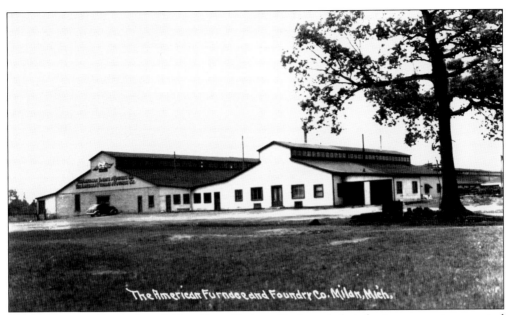

The American Furnace and Foundry Co. Milan, Mich.

In 1920, some officials from Milan State Savings Bank and their business associates started American Foundries Company. It manufactured railway castings and home furnaces. The facility was built along the Ann Arbor Railroad at Ash Street, north of West Main Street. The company worked with Sears, Roebuck and Company and Montgomery Ward, so sales were terrific. The foundry was closed in the late 1970s and partly replaced by new condominiums.

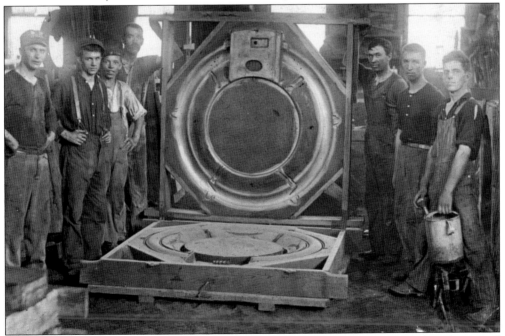

Employees at the American Foundries Company stand next to a sand mold, ready to be poured with molten iron, about 1925. The work was difficult and unpleasant, especially in the heat of the summer. Some men were injured or even killed doing foundry work. Most of the workers felt lucky, though, because the pay was so much more than they could make anyplace else.

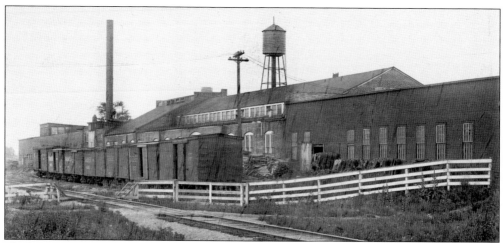

Ideal Furnace Company provided well-paying jobs to men from all over the Milan area during the first half of the 20th century. Farmers loved to work there in the winter and make a nice bundle. Milan residents loved the Ideal foundry so much that they named a street after it. This building on Plank Road at Dexter Street was originally built by Walter F. Stimpson for his scales, and then it was home to Detroit Register Company before Ideal took it over. Some of this building still stands. (Photograph by Frank Pesha.)

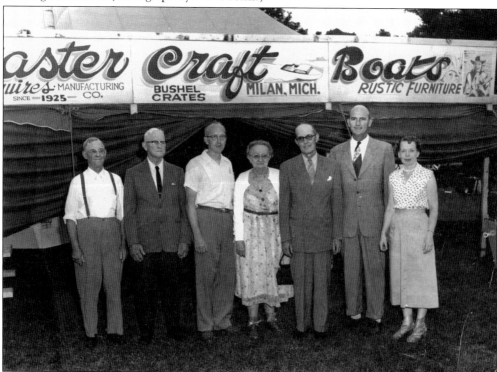

Milan's local inventor Arleigh Squires promotes his Master Craft boats at the Milan Fair around 1948. Surrounded by his business associates and family, from left to right, are Harmon Holmes, Roy Richards, Squires's brother Bill H., Squires's wife Martha, Squires, son Arthur Newton (Newt), and his administrator Calista Craig. Log house kits were also available for the ambitious. One Squires log building still stands in the Milan area on County Road at U.S. Route 23.

Three

DOWNTOWN MILAN

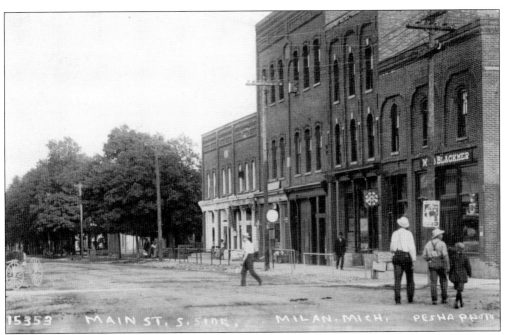

This is the south side of Main Street around 1910. Webb Blackmer's grocery store on the corner of Wabash Street displays a sign at the far right. At that time, it was called River Street. Notice the hitching posts alongside the dirt street. These retailers had little need for large signs to advertise their businesses; everyone knew where they were.

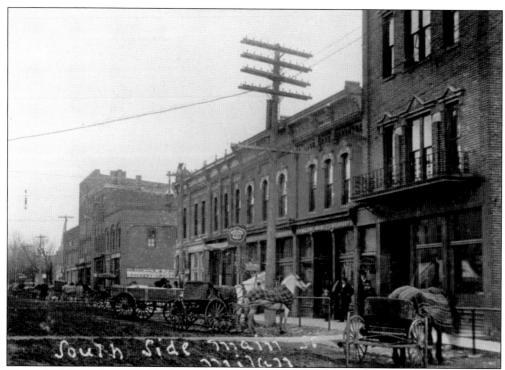

Horses huddle under warm blankets in downtown Milan. Frank M. Miller opened his drugstore in September 1900, and this picture was made soon after. The grocery store on the southeast corner states, "Hitchcock and Far," referring to Milton Hitchcock and Will Farmer, both sons-in-law to merchant Charles M. Blackmer.

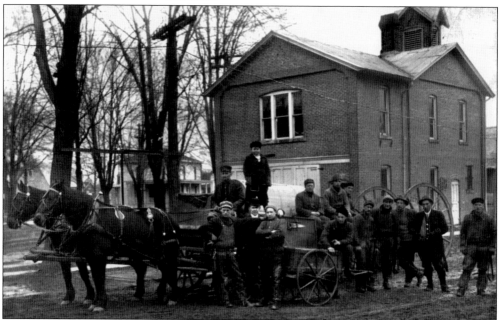

Horses pull equipment past the Milan Village Hall in 1915, as men prepare to install electric wiring. The large wheels in back carry a spool of wire. (Photograph by George Weller.)

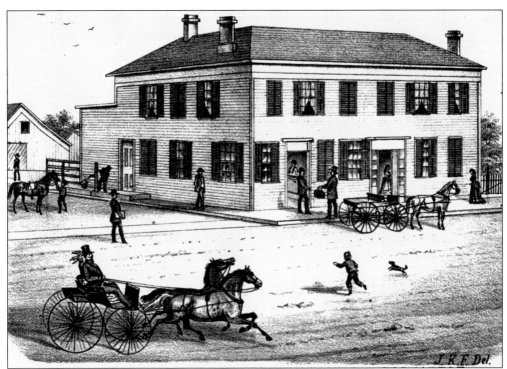

Sometime in the early 1870s, Lyman Burnham took over the Babcock Hotel, calling it the Milan Hotel. A wooden structure, it stood on the northeast corner of Main Street and Tolan Street. This idealized drawing from the 1874 Washtenaw County atlas does not do it justice. When the building was cut in half and hauled away in 1896, there was room for a brick shopping mall in the same space that included a men's clothing store, a hardware store, and a grocery.

This wooden structure was known as the Babcock Hotel in its later years, but it was owned and operated by George and Mary Whiting early on. This tintype photograph of the hotel may be from as early as 1860. Hotel owners sometimes raised chickens behind the hotel so guests could enjoy delicious chicken dinners upon request.

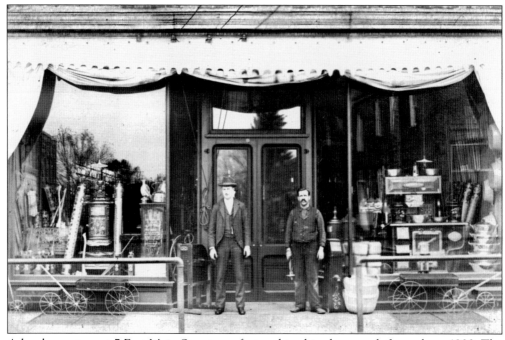

A hardware store at 7 East Main Street was featured in this photograph from about 1900. The hardware owner, Homer C. Sill, must be one of the two men standing at attention at the front door. He bought the Babcock Hotel on that corner for $61 on February 24, 1896. In just three weeks, he had the wood-frame hotel sawed in half, with the two pieces sold, and then he sold the empty lot to George Minto for $1,200.

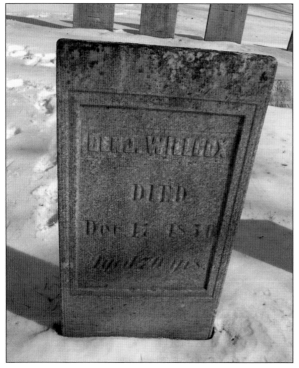

Benjamin Wilcox, one of the first settlers in Milan, was born about 1785. He and his wife, Betsey, received a homestead of more than 156 acres in Milan Township just south of the new community. He helped turn Milan into a town by selling an acre of his land to Elijah Ellis in 1836. Ellis immediately built the first store in Milan. Wilcox is shown resting at Spaulding Cemetery just south of Milan; the gravestone states he died in 1850 at age 70.

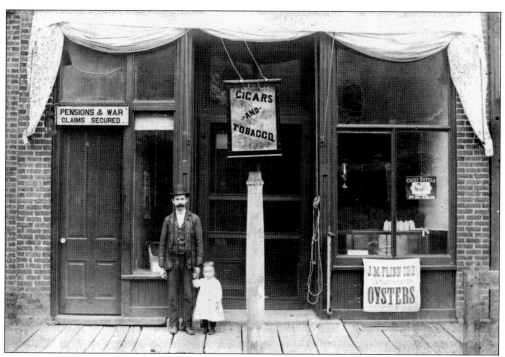

William Woolcott sold ice cream, candy, and tobacco products at 17 East Main Street. His business is captured here by a photographer about 1900, while he holds the hand of his little girl Naomi. The sign reads, "Cigars and Tobacco." In addition to candy and smokes, he sold fresh oysters. Fresh oysters were popular all over the Milan area; it almost looked like a seaside town.

Milo Owens, owner of the Garrick Theater on East Main Street, pauses by his car in front of his business in 1926. He was proud of his theater and perhaps even more proud of his brand-new Chrysler sedan. The store east of his theater was built by J. Henry Ford, a Mooreville retailer. Customers entered the store in the center, but the doctor or lawyer with an office upstairs had a separate entrance from the sidewalk.

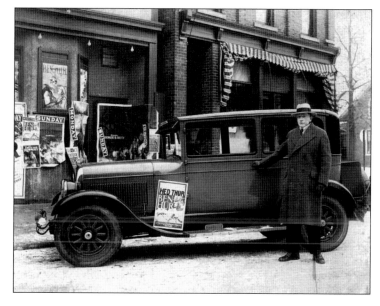

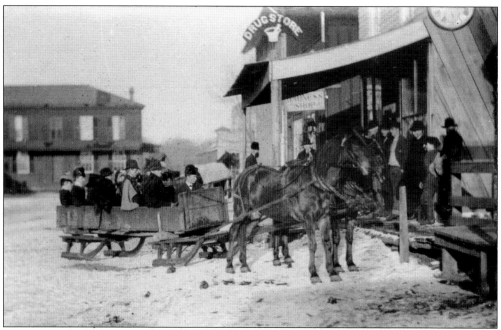

Through early tintype photography, this scene shows a sleigh parked on River Street, now Wabash Street, facing east. The view looks north towards downtown, and the wooden Babcock Hotel is the prominent two-story building on the left. The date could be about 1865. The sleigh is facing a drugstore, where a bank is located today.

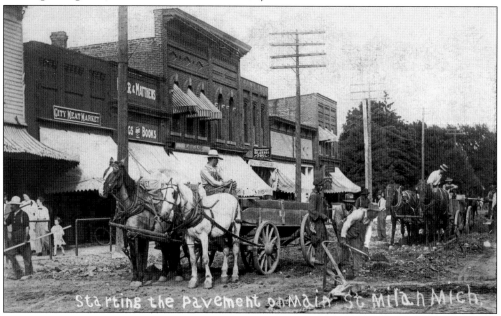

In July 1912, the citizens of Milan village were fed up with having a dirt road going through the center of town. They had water and sewer lines installed, and now it was time for pavement. These horse-drawn wagons had something to do with leveling the dirt and preparing it for the paver bricks. The street signs show a meat market, a drugstore that sells books, a pool parlor, a doctor's office, a dentist's office, and at the end is probably a variety store.

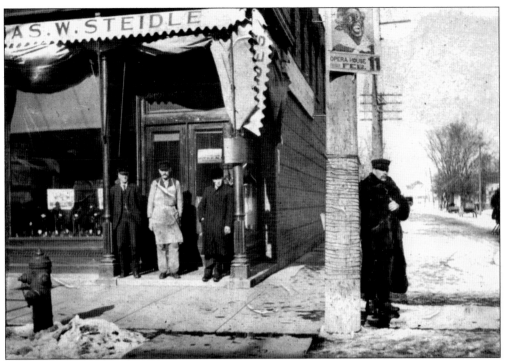

On a cold day in January 1910, store owner Charles W. Steidle steps outside quickly for a picture in front of his shop. He made his living selling shoes here on the north side of Main Street at Tolan Street. He stands on the left, with store cobbler Dick Keremy in the center with an apron. A poster overhead advertises a fun show coming up at the Arnot Opera House, just a few steps away on Tolan Street.

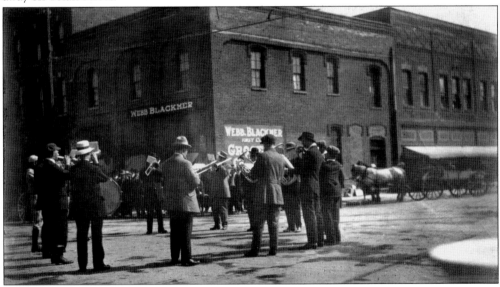

Utopian band members form a circle in the center of town and put on a public performance. With the water fountain in the foreground, Alfred E. Putnam's new dry goods store dominates the storefronts on the east side of River Street (now Wabash Street). Notice the crisscross brick design at the top. That building is now a bank; the second floor was removed in the 1960s.

Sarah Boguslawski Gay's home displays lovely architecture around 1920. The home is found at 141 County Street on the corner of Gay Street. Sarah Boguslawski was born in 1870 in Milwaukee, Wisconsin. She married William Henry Gay of Milan and had a son by that name. However, he died as a young adult. In her will, she left her home to her brother Ben for his lifetime and then to the village of Milan for the Sarah Gay Memorial Hospital. She died in 1940, and the village of Milan never established the hospital.

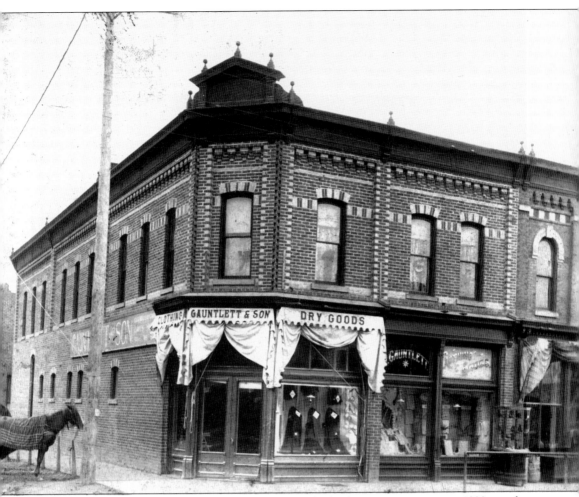

William Whitmarsh, a successful Milan merchant, built this spacious store in 1899 on the southwest corner of the downtown. Elon D. Gauntlett and his second wife, the former Addie Van Wormer, were operating a dry goods store here in December 1903 when the photograph was taken. Gauntlett's father, James, must have been involved because the sign reads, "& Son." The building still stands, with the outside remodeled only slightly.

A sign advertises a local beer, L. Z. Foerster, from a brewing company in Ypsilanti, as a lager beer. Charles Schmitt and another gentleman pose in front of the saloon around 1900, which was located on the east side of River Street, now Wabash Street. The saloon has been replaced by a bank.

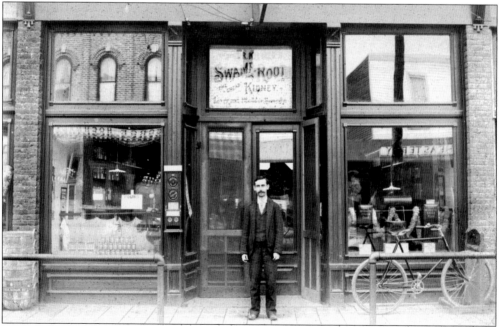

Orrin A. Kelley stands proudly in front of his hardware store in about 1900. This shop is still there at 9 West Main Street. Note the mechanical vending machine for chocolate candy to the left of the front door. "Drop one cent, push the rod," the sign states. Kelley sold windmills, stoves, and paint. Over the door, an advertisement reads, "Swamp Root, The Great Kidney, Liver and Bladder Remedy." It was just the right product for a hardware store.

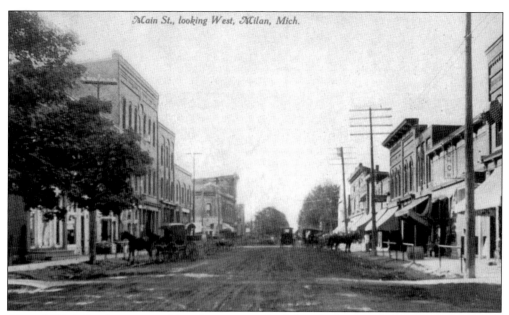

About 1911, ladies hats were sold in the store on the left with the steps. After that, there was a harness shop, jewelry store, dry goods business, and a saloon. The last three shops on the south side were a pool hall, a barbershop, and a grocery store. On the north side, on the right, a variety store, a 5¢ theater show, a grocery, a butcher shop, a candy shop, more groceries, a drugstore, a post office, a candy shop, a barber, groceries, a hardware store, and a clothing shop at Tolen Street. Those stores were identified on a fire insurance map of the time.

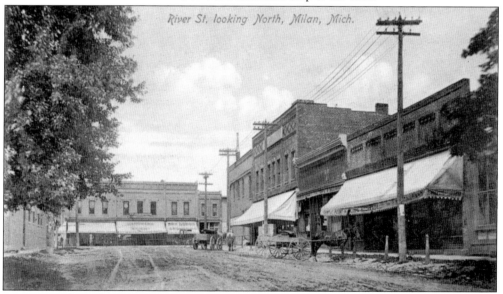

By 1900, Milan's downtown buildings were in place, most of them surviving to the present intact. This view from River Street looks north at Main Street. Storefronts on Main Street, from left to right, are Minto's clothing store for men, Homer C. Sill's hardware, and the W. S. Juckett grocery. On River Street, starting at the corner, are Webb Blackmer's grocery store, Alfred E. Putnam's dry goods store, Charlie Schmitt's saloon and billiard parlor, and Louie Hockradel's restaurant and sample room in the foreground. (Photograph by George Weller.)

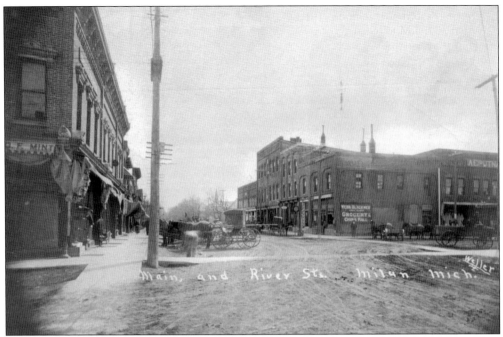

Looking east from Tolan Street, photographer George Weller got a great postcard view of East Main Street around 1909. The street is dirt, but the sidewalks are paved. A barber pole has popped up on the south side of Main Street between the Blackmer grocery and the jewelry store. The Alfred E. Putnam dry goods store dominates Wabash Street on the right side of the picture. The building still stands, minus the second floor, and is home to a bank.

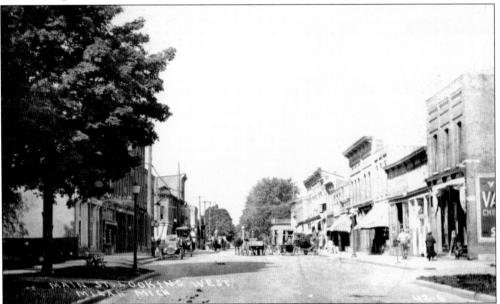

By 1921, Milan's downtown stores took in customers who arrived by horse and carriage, by gasoline-powered vehicles, or by walking. Visitors also came to Milan by train and spent the night in one of its several hotels. Elegant streetlamps shown in this photograph kept the area safe at night.

A 1916 Model T Ford is parked on the curb outside Miller Drugs on West Main Street. A sign in the drugstore window mentions Kodak products. To the right, Farmers and Merchants Bank is ready to take in deposits. A stairway between the drugstore and bank has a sign advertising either a lawyer or doctor on the second floor. To the right, the post office occupies a former alley, which now has a roof over the top. The date is about 1918.

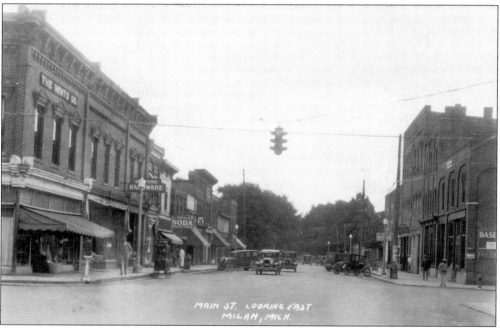

This photograph is facing east in downtown Milan in the 1920s. Minto's men's store is on the left next to the Sanford hardware store. Sanford's was on the ground level in this photograph but was later moved upstairs. A barbershop is next, then a candy shop and a drugstore. On the south side of the street, two candy stores are seen, but the remaining stores cannot be identified. A sign points to Toledo.

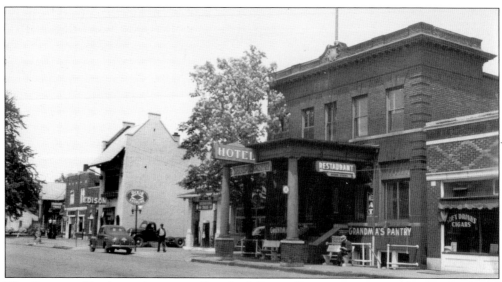

The Stimpson Hotel, now known as Grandma's Pantry Restaurant, is seen about 1945. Notice the hotel still included the portico over the sidewalk. Pearl Draper had a reputation for great food at this downstairs eatery, especially for her homemade pies. Note the Dixie gasoline station west of the hotel, then the Edison office and another gasoline station. The area west of the hotel is a parking lot today.

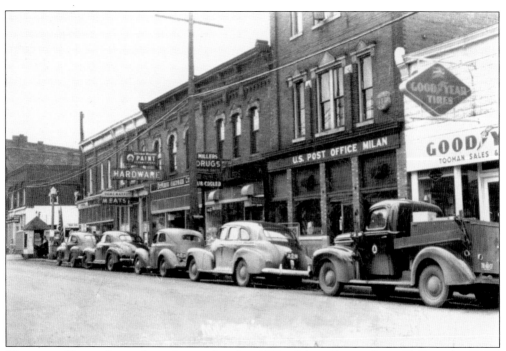

The post office is featured on the south side of West Main Street about 1948 in the IOOF Building. Cars are squeezed into parking spaces, by their adjacent meters, which attest to the popularity of Milan as the place to shop. DeMerritt Hardware occupies a space originally built for a hardware store. Next to it is a butcher shop, and then finally a clothing store or department store is on the end. The little kiosk belongs to the police.

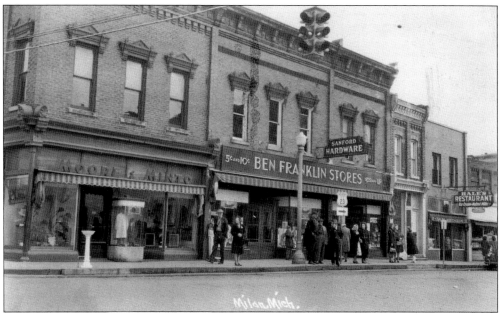

The Ben Franklin store dominates the north side of East Main Street in 1944. To the left is Moore and Minto men's clothing store, with the legendary downtown drinking fountain out front. Sanford's hardware is upstairs, well equipped with hardware for farmers. A woman is seen stepping into Ty Woolcott's barbershop to the right of Ben Franklin's. The next store is Hale's Restaurant and then Don Conklin's Rexall drugstore. At this time, U.S. Route 23 runs north into Milan, then turns right at this corner, continuing north again on Dexter Street.

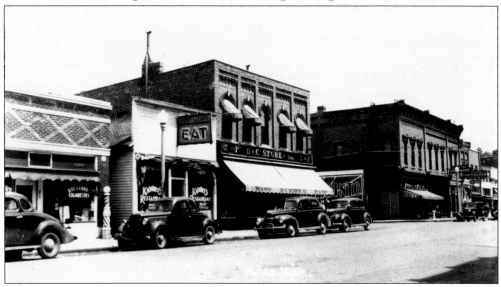

Here is a clear view of the shops on the north side of Main Street around 1941. Knights Restaurant, with the sign "Home Cooking, Eat," occupies a wooden building, a rarity in the downtown and one of the oldest structures. On the left, a brick building features a crisscross brick pattern, which must have come from the same bricklayer who worked on the Alfred E. Putnam store on Wabash Street. As the image documents, Moore and Minto's store was still a landmark on the northeast corner of Main and Tolan Streets.

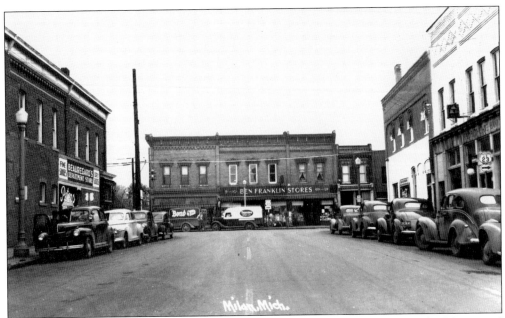

This is Wabash Street in January 1947, looking north at Milan's downtown. The Moore and Minto store is straight ahead, and the Ben Franklin store is on the right. Some children gaze out of an upstairs apartment window. Beauregard's Department Store advertises shoes and dry goods on the southwest corner. U.S. Route 23 signs are prominent; the highway went through the center of town. This continued until 1963, when a limited-access highway was built outside Milan.

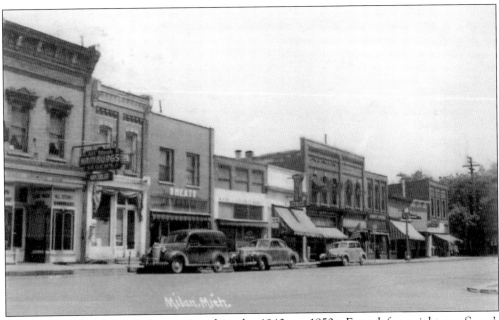

The north side of East Main is pictured in the 1940s or 1950s. From left to right are Seger's hamburgers, a barbershop, Sheat's meat market, Rexall Drugs, unidentified, and Kroger's grocery store. Bassitt's department store is on the end past a shoe repair shop.

Four

FUN AND GAMES

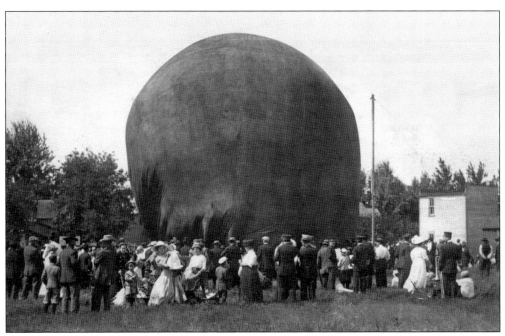

The homecoming festivities needed an uplifting experience, so a leather balloon seemed perfect for the occasion. This required a bonfire, which was allowed to die down. The balloon was laid across the embers to fill with hot air. Some people went up in the air until the balloon cooled, then it came down on a tether back to the launching pad. A band from Milan or Azalia performed. This happened on September 11, 1912, probably on vacant land near the high school on Hurd Street.

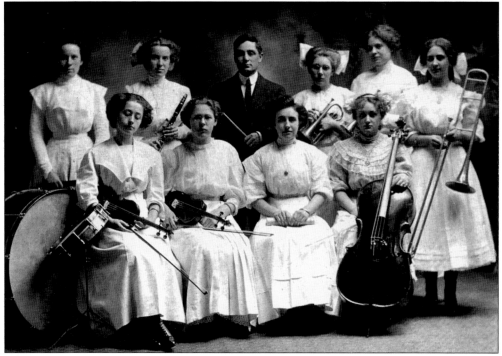

Since girls were not allowed to play in the school band or orchestra, they started their own group outside the school system. Milan had the Orchestra Girls. This group participated in parades and performed everywhere. Shown in 1912 from left to right are (first row) Helen Heston, Maureen Loveland, Clyde Nase (Lawson), and Gertrude Gay; (second row) Hazel Hartwell on drums, Iva Lee (Sanford), director Professor Morrison of Adrian, Maureen Miller (Phillips), Hazel Cook, and Linda Nase (Hazlett).

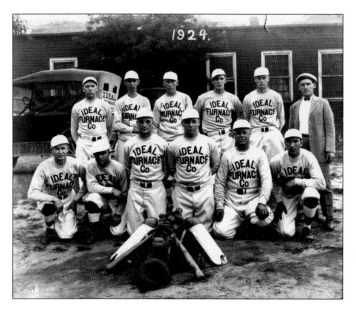

The Ideal Furnace Company on Plank Road at Dexter Street took baseball very seriously in 1924. Plenty of businesses had their employees competing in leagues, wearing first-rate baseball uniforms. From left to right are (first row) Jay Hoskins, Paul Trim, Robert Button, Leroy Phaler, Elmer Dennison, and Harvey Norman; (second row) Harry Hamlin, Donald Hoover, Clarence Kanitz, James Norman, John Auten, and manager George Dresser. (Photograph by Leonard Cook.)

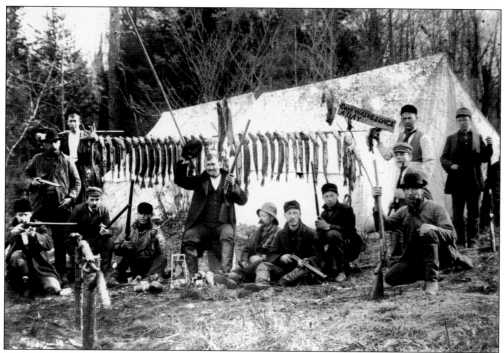

Milan business owners got together for male bonding through the Knights of Pythias, the Masonic lodge, and the IOOF. In addition, they got together in the woods from time to time to gather the bounty of nature. Drugstore owner Frank Miller can be recognized on the far left, standing with a gun. A man never knows when he will need a gun on a fishing trip.

Milan waited until 1885 to incorporate as a village. Why did it wait so long? Probably because the secret societies ran the show. The Masons, the Knights of the Maccabees, the Knights of Pythias, the IOOF, and the Woodsmen all guided the town. Also GAR members were veterans of the Civil War. A schedule was needed in the *Milan Leader* to keep track of them all, like this item published on January 4, 1889.

SECRET SOCIETIES.

LUCIUS TAYLOR POST No. 274, G. A. R. Regular meetings 1st and 3d Wednesday nights of each month. W. ROBISON, Com.
A. D. JACKSON, Adjt.

MILAN LODGE No. 323, F. & A. M. Regular meetings Thursday evening on or before full moon. All brothers of the craft are cordially invited to attend. H. M. BURT, W. M.
D. A. JENNINGS, Sec.

WOLVERINE LODGE No. 197, I. O. O. F. Meets every Saturday night at 8 o'clock at their hall in the Blackmer block. All members of the Order cordially invited.
W. H. WHALEY, Sec. ASA WHITEHEAD, N. G.

CHAMPION TENT No. 42, K. O. T. M. Regular reviews 1st and 3d Monday evenings in each month. Brothers of the Order cordially invited to attend when in town.
 S. C. HUNT, Com.
CHARLES WHITING, R. K.

Elon D. Gauntlett designed his building at 39 West Main Street for roller-skating on the upper floor. What better time than Halloween to show off costumes on roller skates. Notice above their heads in the middle is a basketball hoop. It was 1910, and the second floor above the Reo dealership doubled as a basketball court. It was tough playing the game in there with those low ceiling joists until the school built a gym.

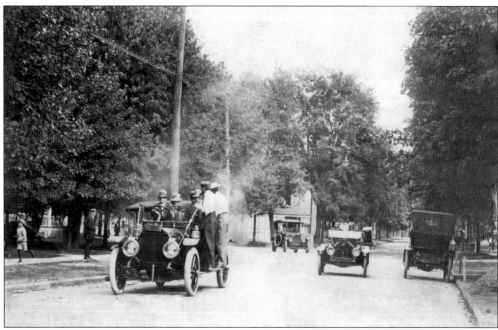

New cars whiz by on East Main Street in front of the fire barn in 1912. All these cars were crank-started. On the left side in the lead is a 1911 Welch, with several young men on the running board, heading westbound. The next car, in front of the fire barn, is a 1912 Buick Model 35 with a spare tire on its side. The car with the crank straight up is a 1912 Little. The parked vehicle facing east is unidentified.

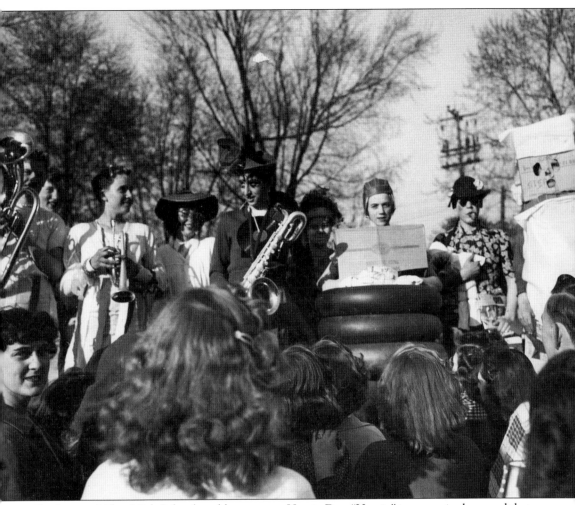

Students at Milan High School could not escape Hemio Day. "Hemio" is a meaningless word that sounded a tad Greek, and it was a day for hazing the 10th graders. In the spring of 1949, Dave Lentz is on the left holding a baritone, with his hair in curlers; Jerry Cook holds a trumpet, with his hair in curlers; Phil Hawarny wears a dress and heavy makeup while holding a saxophone; Mildred Gardner sits in a pile of inner tubes; Doug Edwards wears a dress and dark glasses, holding a doll. Hemio Day was abolished a few years later because the hazing got out of hand.

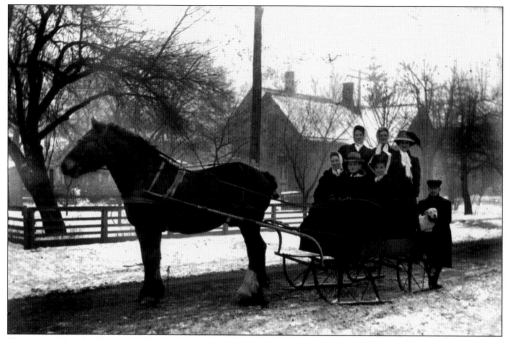

Enjoying the fresh snow downtown, someone stopped a sleigh on Ferman Street in front of photographer George Weller's studio for a quick photo opportunity. It was 1910, and the white stuff was gorgeous. Samuel Draper stands behind the sleigh with a dog in his arms. From left to right are (front seat) Miss Walker, an employee of Gauntlett Dry Goods; Elon D. Gauntlett, store owner; and his wife, Addie VanWormer Gauntlett; (back seat) unidentified, Katherine (Kit) Guy, and Cora Draper.

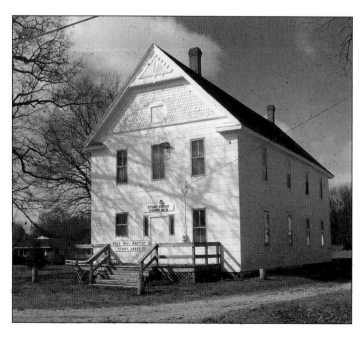

This is the Grange hall as seen today in Stony Creek. This community first got the name "Pokey Grab" for reasons lost to the mists of time. A fair number of Scottish settlers came to the area, and the first church in Stony Creek was Presbyterian. That church is no longer standing. The Grange hall served as a community house and get-together point for area farmers, who cooperated in the sale of certain crops. A kitchen was built on the first floor, and a dance hall was on the second.

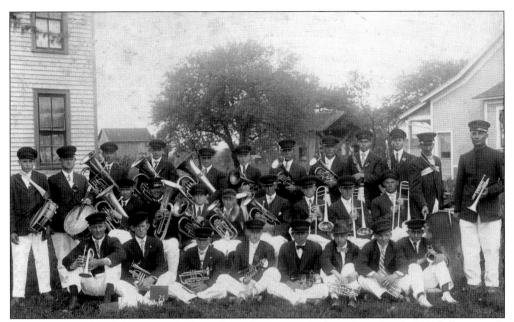

Frank Lamkin, band director, stands on the right next to the bass drum for this 1915 photograph of the Azalia Village Band. Farmers of all ages within about 10 miles enjoyed giving concerts and marching in parades. Arleigh Squires is seated in front, fourth from left, holding a trumpet.

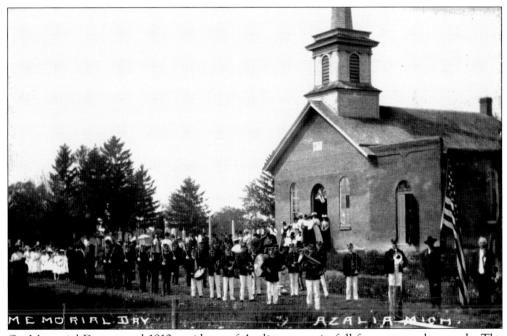

On Memorial Day around 1912, residents of Azalia are out in full force to see the parade. The crowd is gathered at the south end of downtown alongside the Methodist Episcopal Church, which was established in 1856. Members constructed the brick building in 1870. The cemetery in the background is just south of the church.

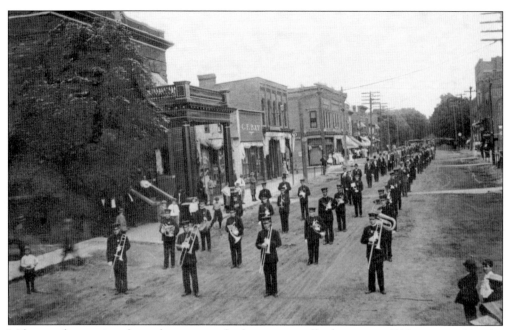

Milan residents enjoyed parades on a regular basis, especially this one in 1911 sponsored by the Knights of Pythias. The Milan Utopian Band is marching here. The trombones are in front as the band heads west past the Hotel Stimpson on West Main Street. The Knights of Pythias were popular at the dawn of the 20th century. Members had a political impact and looked after funerals for any brother who passed on.

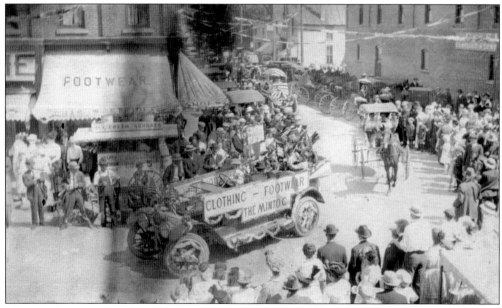

The parade is turning onto West Main Street from Tolan Street about 1916. The Knights of Pythias usually put on a fabulous parade every year. The sign on the float, driven by a lady, reads, "Clothing Footwear The Minto Co." Behind the lady, a bunch of children are dressed up with feathers to look like Native Americans, playing flutes or pipes. A sidewalk vendor advertises "Velvet Ice Cream, Get a large filled cone 5¢."

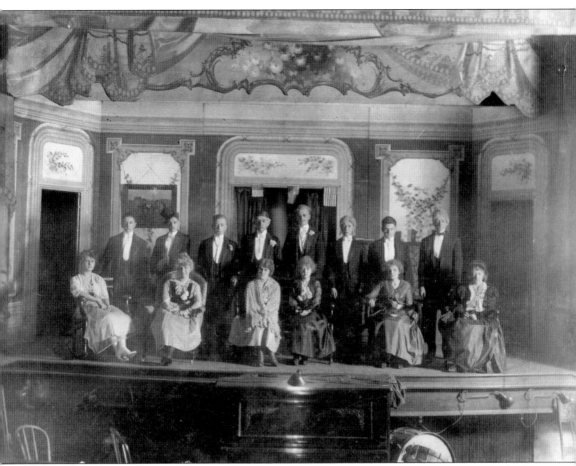

For many years, the Arnot Opera House on the west side of Tolan Street was a mainstay for high school plays. These students pose in 1918 just above the orchestra pit in full costume. The opera house also provided a central downtown theater for silent pictures, minstrel shows, concerts, and vaudeville. There was never any opera shown here. Milan actually had two opera houses, including the Gay Opera House on East Main Street. The opera houses fell onto hard times with the advent of radio. The Arnot finally burned down on February 16, 1941. No one was injured. A parking lot entrance takes up the space where this building once stood.

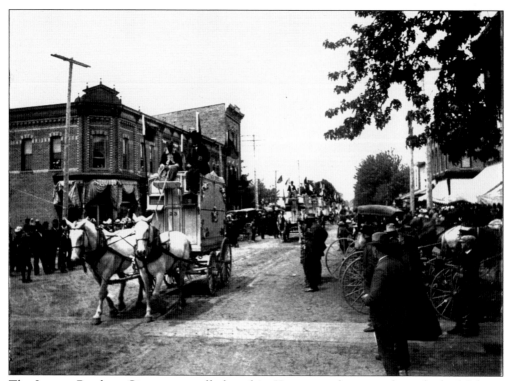

The Leman Brothers Circus, normally based in Kansas, took a tour through the Midwest and is seen here on parade through downtown Milan about 1898. Throngs of onlookers crowd the sidewalks near their horses and buggies. This circus was huge—wagons are visible approaching from the west far into the distance. The horses in front were probably brown or grey and dyed white.

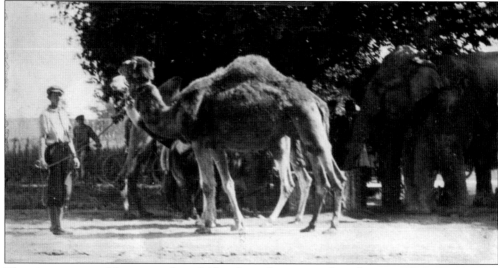

The circus attracted huge crowds to Milan from the surrounding farms in 1913. Circus tents spread out, perhaps along Hurd Street near the school, or in the fairgrounds owned by Charles Gauntlett. Teenager Rolland Drake snapped this picture of a circus camel with his own camera. He glued it into a scrapbook for safekeeping.

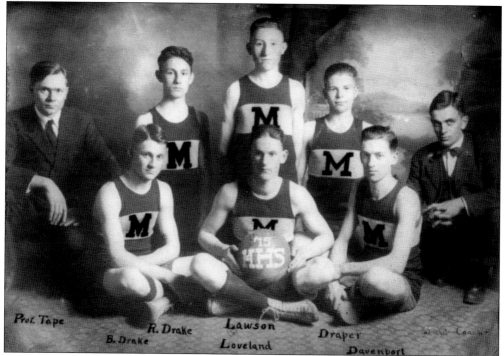

Milan High School was proud of its boys' basketball team in 1915. Pictured from left to right are (first row) seniors Byron Drake, Stanley Loveland, and Ward Davenport; (second row) professor Tape, Rolland Drake, Milton Lawson, Walter Draper (all three sophomores), and coach Dale.

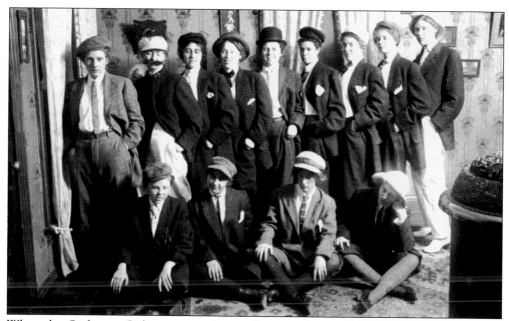

When the Orchestra Girls were not playing their trombones and violins, they were getting together for crazy, wild parties. This one on March 18, 1912, got so silly that they had to bring in a photographer. Ruth Dexter invited her musical pals to her house for a "stag party."

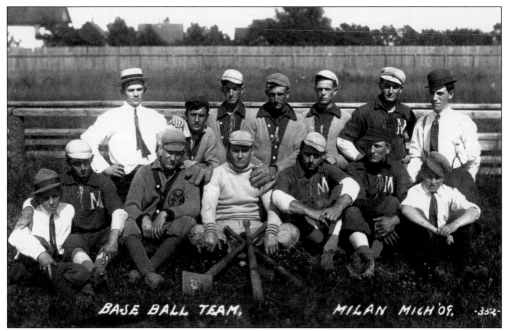

The Milan baseball team looks sharp in 1909 with snazzy uniforms and bats piled in front. Mostly farmers, they played hardball on Sundays. The team assembled for this photograph on a racetrack belonging to Charles Gauntlett. Referred to as the fairgrounds, this was the place for baseball tournaments in addition to horse races. Gauntlett was born on this land in 1853 across Platt Road from the cemetery. Today the fairgrounds area is an apartment complex.

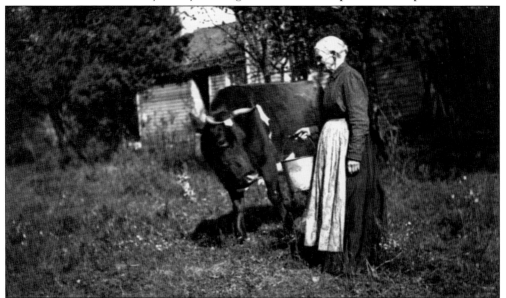

Maria Warner, born on August 9, 1820, was one of the oldest living residents of Washtenaw County when someone caught her in this photograph in 1915. A book about the county explains that she arrived in Milan with her father back when settlers from New York had Native Americans for neighbors. Her husband, Homer, died in 1900. Her favorite hobby was walking around barefoot in the summer with her cow. Her home was opposite a present-day grocery store.

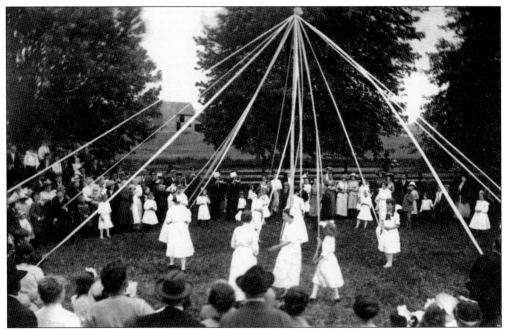

This lovely maypole dance was executed near Willis on May 9, 1913. The Milan Utopian Band is on hand in full uniform to provide music. A professional photographer attended the celebration, making his living by selling postcards of local interest. Photographers seldom visited a rural area like Willis, so this view of Augusta Township farm life is a rarity.

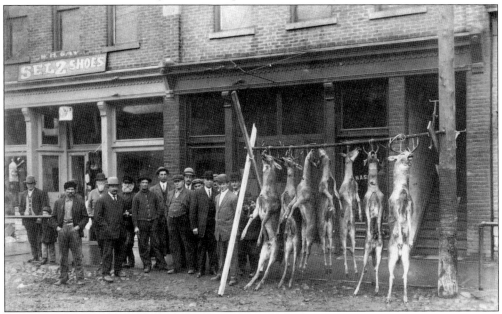

Business owners socialized with each other by joining the Knights of Pythias, the IOOF, the Masons, and many other such organizations. But they also enjoyed socializing with guns in the woods, where male bonding could occur. Here is a group of Milan businessmen displaying the bounty of their efforts in 1903 in front of Nace's Saloon at 28 East Main Street. Nancy Nase, saloon owner, is fourth from the left with a tie and round hat.

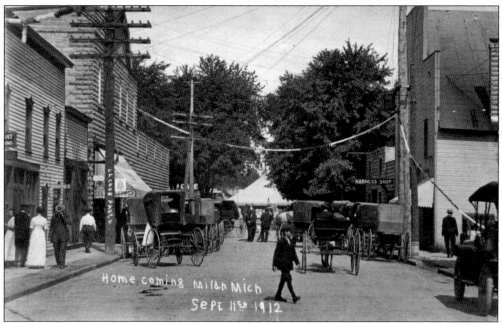

Looking north on Tolan Street, the tents near the school are visible in the distance. Homecoming brought a crowd of former students and their families to Milan in 1912. On the left, the Arnot Opera House dominates the storefronts with its arched roof. The opera house never showed a single opera. It was the place for school plays, graduations, minstrel shows, silent movies, and concerts. Its popularity fell with the rise of television. The Arnot Opera House burned down on February 16, 1941.

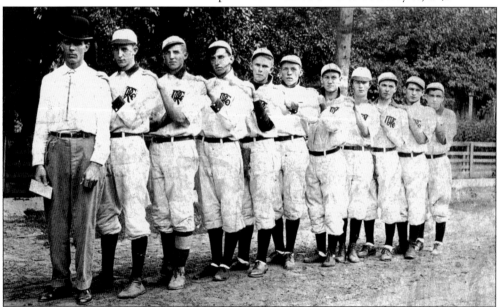

Detroit Register Company supplied some spiffy uniforms to employees on the company baseball team. They are posing here around 1910, probably at their manufacturing plant on the north side of East Main Street at Dexter Street in the former Stimpson Scale factory. The Detroit Register Company was making metal registers for furnaces. Walter A. Smith, at the very end, was born in 1889 and eventually established the Smith Foundry on Wells Road south of Milan.

Reuben Westfall, a Mooreville farmer, pauses in front of the grandstands at the fairgrounds for a formal portrait with his racehorse in the early 1900s. Charles Gauntlett sold his shoe store in 1892 and devoted himself to racehorses, building this track on his property. He welcomed baseball tournaments as well. Gauntlett stopped owning horses in 1905. The fairgrounds were torn down about 1916.

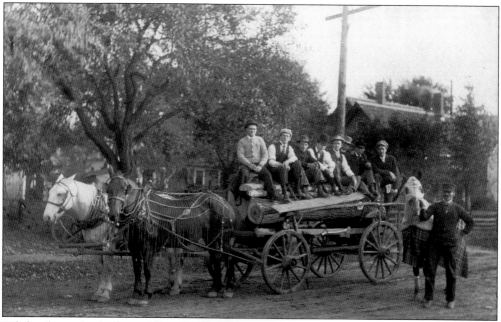

While taking a load of logs to the sawmill, these gentlemen pass by the George Weller photography studio on Ferman Street and decided to memorialize the occasion around 1910. From left to right are Sears Thurlow Blackmer, clothing store owner; unidentified; James Hack; and the rest unidentified. The racehorse is shown on the right, probably going to or from the private Charles Gauntlett racetrack at West Main Street and Platt Road.

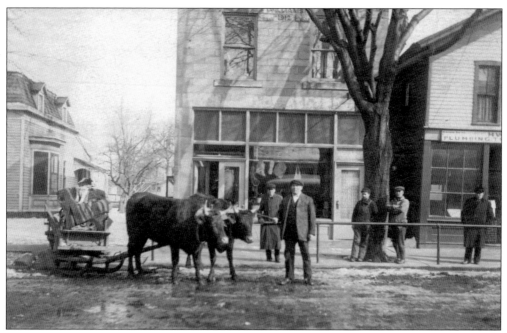

Herb Braman stands in front of his butcher shop on the north side of West Main Street in March 1912, showing off the pair of oxen he just bought. These animals are known for pulling heavy loads with little effort, and Braman found them irresistible as his new hobby.

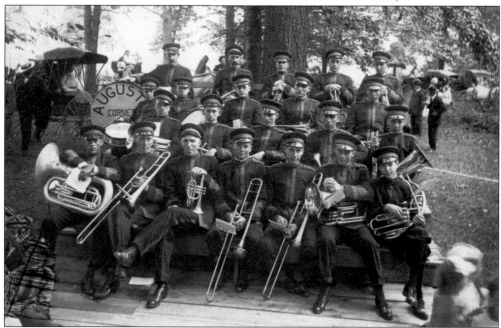

The cornet band in Augusta Township looks sharp in shiny hats and shoulder blades. A farmer who wanted to play his cornet for fun was willing to pay a little money for the uniform expense so the group would look as snazzy as they sounded. This band did not need microphones or speakers. They had at least 20 brass players and some percussionists, so they were heard for quite a distance.

Five

FLOUR MILL, RIVER, AND LAKE

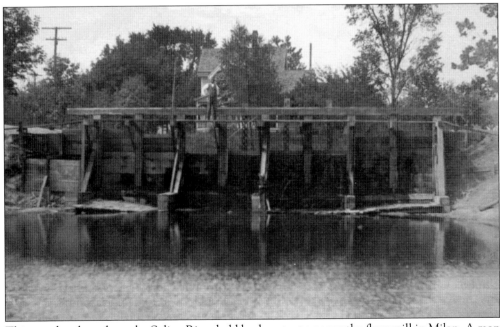

This wooden dam along the Saline River held back water to power the flour mill in Milan. A man stands on the bridge, looking down at the water. The photograph was taken in August 1910.

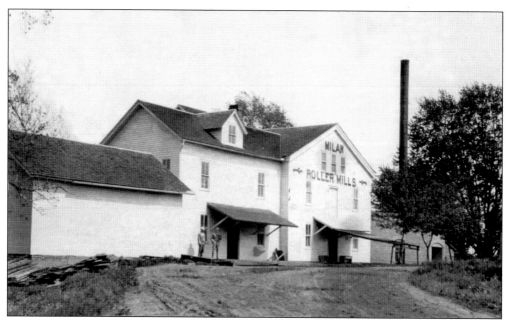

In 1834, David Woodard set up a flour mill in Milan in partnership with William Marvin. Power came from the Saline River. By 1850, Isaac Gay was in charge of the flour mill. Thomas Wilson, an Englishman, came to Milan in 1856 and took it over. Wilson's son Charles was running the place when this picture was taken around 1900.

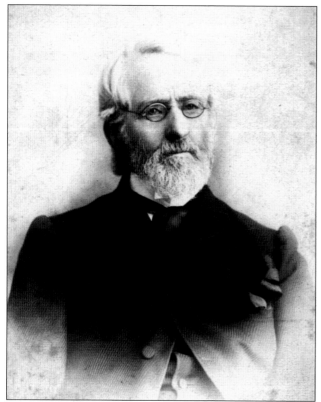

Thomas Wilson, known for operating Milan's flour mill, is photographed here in 1894. The mill itself was built in 1834 by David Woodard and owned by various families before Thomas came to Milan in 1856. He lived near the flour mill with his wife, Jane Dodge Wilson, and their three children.

Charles H. Wilson was elected Milan village president on March 11, 1897. He was a prominent businessman, owning a flour mill and sawmill along the Saline River. In 1890, he had enough extra cash to purchase 15 shares of stock in the new Farmers and Merchants Bank at $100 a share. For several years, he served as village coroner. His daughter Grace married Wilmer F. Butler, a partner with shoe retailer Charles Gauntlett. In 1921, Charles donated land to the village for a park known today as Wilson Park.

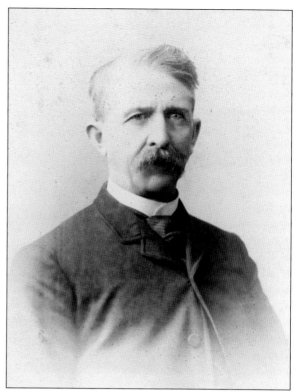

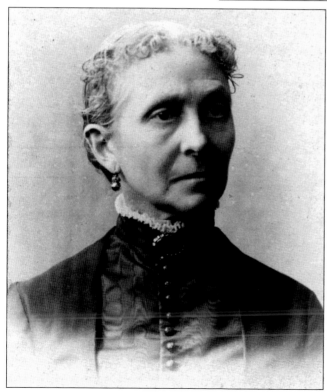

Alzina A. Mead came from an area of Milan Township known informally as Meadville because the family owned so many farms on Mead Road. In 1867, she married Charles H. Wilson, son of English immigrant Thomas Wilson. Both father and son operated a flour mill along the Saline River. Their sawmill ran partly on waterpower and partly on steam. Alzina and Charles had two children, Fred and Grace. Alzina died in 1902.

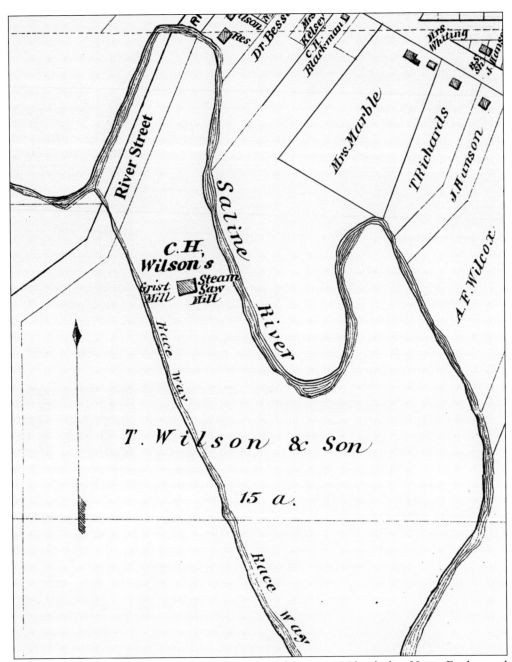

The Saline River zigzagged back and forth south of downtown Milan before Henry Ford moved the river. The 1876 atlas of Monroe County includes an excellent map of Milan, especially the river and the mills. River Street is now Wabash Street. That straight line of water was the millrace, which was man-made. In 1937, it changed completely, as Ford moved the river and dug the lake for his industrial purposes.

Here is Wilson's flour mill, on the east end of Neckel Drive. Water in the left lower corner comes from the millrace and will soon join back to the Saline River downstream. The date is probably about 1905, because the smokestack in this photograph indicates the mill was powered with steam.

Charles Wilson was going full blast with his sawmill in 1882, when he ran this advertisement in the *Milan Sun* on February 18, 1882. The flour mill used waterpower to grind the grist. The sawmill used steam, allowing a high level of production with little regard for the weather. The sawmill was located just west of the flour mill, near the present-day police station.

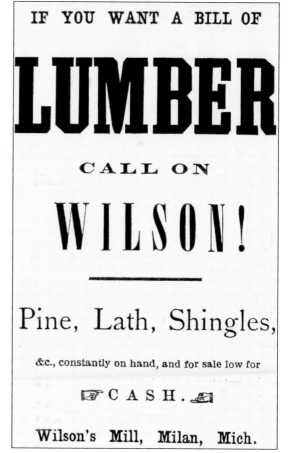

IF YOU WANT A BILL OF

LUMBER

CALL ON

WILSON!

Pine, Lath, Shingles,

&c., constantly on hand, and for sale low for

☞ C A S H. ☜

Wilson's Mill, Milan, Mich.

Myron Wilson is posing on Ferman Street beside his delivery wagon loaded with 25-pound bags of flour. The Wilson mill advertised its flour as promoting beauty in women. The telephone number listed on the side of the wagon reads "27." In about 1912, Wilson's brother Charles ran both the town flour mill and sawmill. Myron worked full-time for the family business.

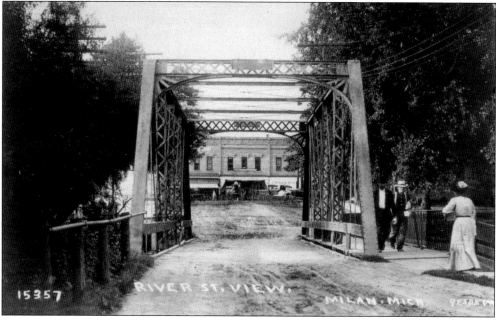

A trestle bridge frames the Milan downtown area in this photograph from around 1900. The metal bridge was installed over the Saline River by Massillon Bridge Company of Ohio in February 1889 at a cost of $275. A walkway on the side allowed pedestrians to follow River Street (now Wabash Street) without getting wet. The bridge had to come down in 1936 as part of Milan's makeover by automobile manufacturer Henry Ford. (Photograph by Frank Pesha.)

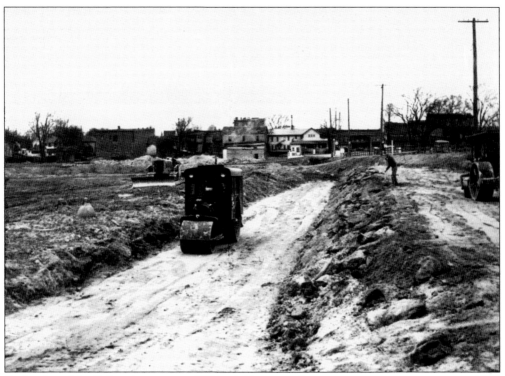

Both sides of the Saline River west of Wabash Street saw heavy construction equipment in 1937. With the dam turned "off" up river, workers could scrape away enough dirt to make room for a lake—"Ford Lake" as it was called. Ford built a series of new lakes and dams in farming areas such as Milan, hoping to harness waterpower for industry. Later generations in the Milan area viewed the lake as a recreational gem, but in Ford's opinion, he was just turning crankshafts.

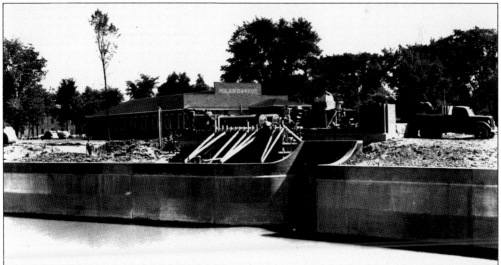

The digging went down for several basements as Ford built his hydroelectric powerhouse in Milan in 1937. This was done at the same time as dredging the lake and installing a new dam. The old Milan Garage is seen behind the construction site, and the former flour mill is visible to the left of it. The power plant, with a few additions, now serves as Milan City Hall.

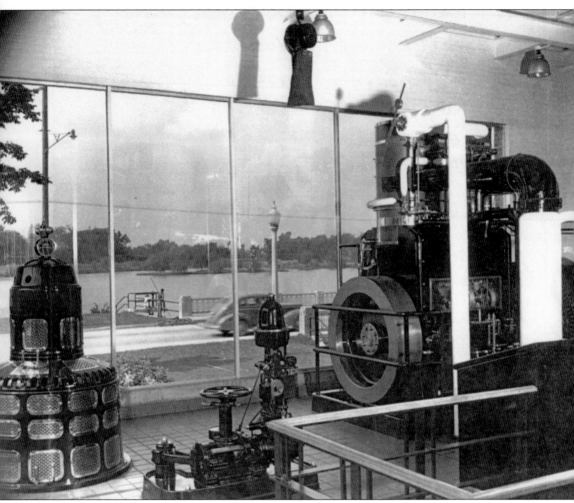

The Ford industry powerhouse gleams in a showcase along Wabash Street, overlooking the new Ford Lake, around 1940. Note the two men with a fishing pole outside the window. Henry Ford set up a series of water-powered industrial developments in rural areas like Milan. The water generator, on the left, was controlled by that little contraption in the middle with the wheel on top. When Ford visited Milan, employees ran the water generator. The moment he left, they switched to the steam generator, seen on the right. The waterpower was not very efficient. This building is known today as Milan City Hall; the room shown in this photograph is now referred to as the "front room."

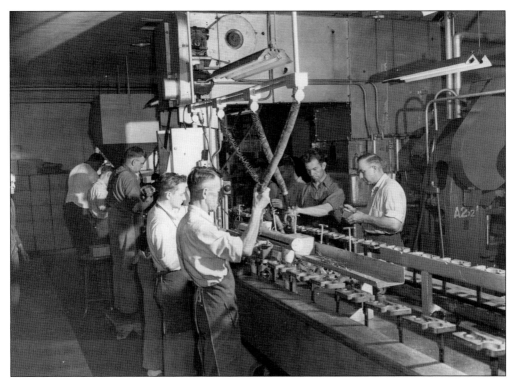

Keeping connected to rural Michigan, Ford built this ignition coil factory in Milan along with other manufacturing sites in farm country. Ford converted an old garage into a factory to supply ignition coils to his automobiles. Farmers could make good money working here in the "off" months and take time to plant or harvest their crops. This structure is now gone; the Milan police station is located nearby. (Courtesy of Benson Ford Research Center at Dearborn.)

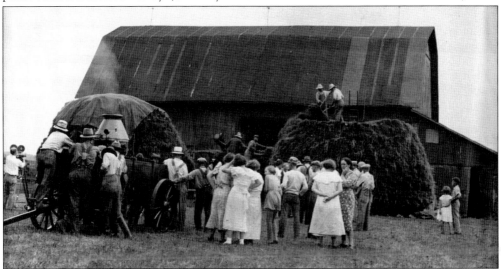

Henry Ford idealized farm life. In the 1930s, he purchased the former Tinsman farm in Milan Township to demonstrate historic farming practices. Note the moviemaker with a reel of film taking it all down as Ford reenacts farm life as it was in the 1880s. Ford manufactured cars as a hobby; farm history was his passion. (Courtesy of Walter P. Reuther Library, Wayne State University.)

Dr. John De Tar enjoyed his moments out on Ford Lake in a boat. This 1950 view of Ford Lake is facing south towards the island.

Shortly after Ford Lake was dredged, winter brought people in droves to try out their skates on the ice. The lake was an instant wintertime success. The lake is still there, as beautiful as ever, but it is filling in slowly with silt through natural processes.

Six

POLICE, FIRE, AND TRANSPORTATION

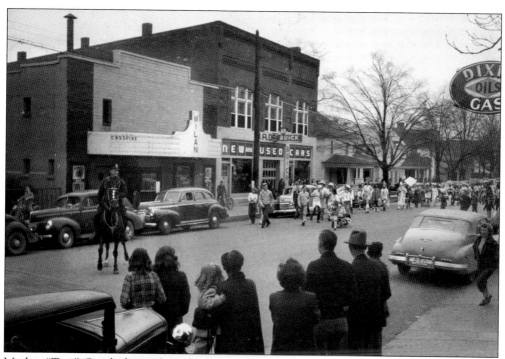

Myrlan "Tom" Goodridge, police chief, is leading the Hemio parade along West Main Street towards the center of town. It was the spring of 1948, time for the annual hazing rituals organized by the high school teachers. Students dressed up in silly costumes for the parade, 11th graders tormented 10th graders, and then they attended the Hemio dance in the evening. The practice was stopped after a few students took the hazing a little too far.

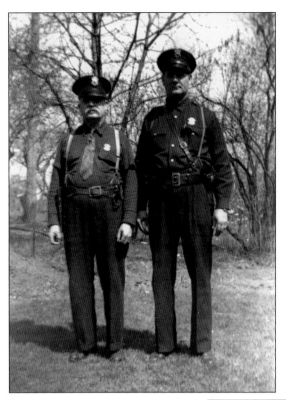

In 1911, Thomas Goodridge (left) was appointed marshal of Milan. A native of Yorkshire, England, he was still on the job as Milan's chief law enforcer in May 1945 when he died. Note the plaid tie, which goes well with his uniform. His son Myrlan "Tom" Goodridge stands on the right. The younger Goodridge started as a traffic patrolman in 1940, retiring as Milan police chief in 1965. He was known as an expert horseman.

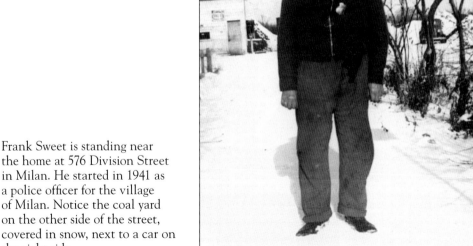

Frank Sweet is standing near the home at 576 Division Street in Milan. He started in 1941 as a police officer for the village of Milan. Notice the coal yard on the other side of the street, covered in snow, next to a car on the right side.

The police chief makes a dramatic figure heading a parade westbound along East Main Street in front of the Atlantic and Pacific grocery store. Myrlan "Tom" Goodridge had just passed Hawarney's Soda Grill, which doubled as the bus station in Milan, and he was in front of Teal's candy shop. Goodridge always led parades on horseback; he was an accomplished horseman.

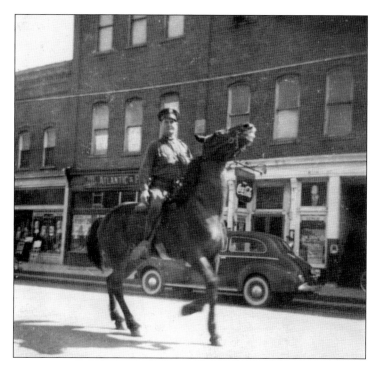

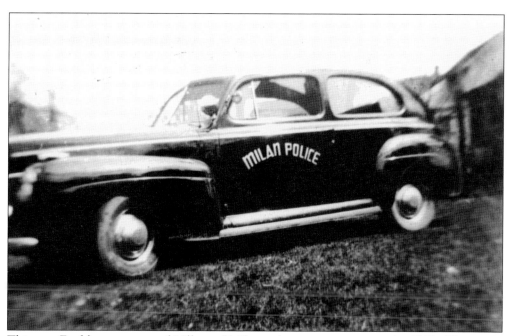

This new Ford became a proud Village of Milan police car sometime in the 1940s. This was a radical change in the way law enforcement was done. Previously the officer would get in his own car, mount his own horse, get on his bike, or walk.

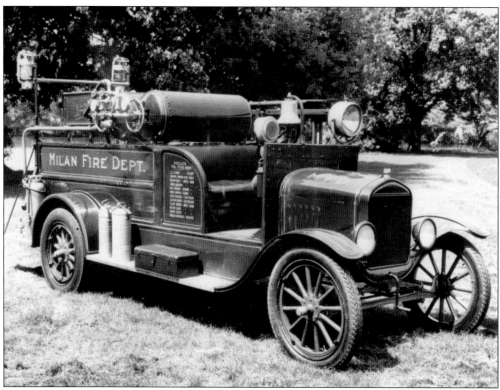

In 1926, Milan village officials bought a fire truck from American La France, with a Ford Model T body, for $3,050. When the firemen took it off the train and tried to crank it up, nothing happened. Then they added gasoline and cranked it up again—it ran like a charm. In 1936, Henry Ford asked Milan to let him have it for his Greenfield Village Museum; the truck is shown here in 1938 just before leaving for Dearborn. Ford gave Milan a new 1938 fire truck in return.

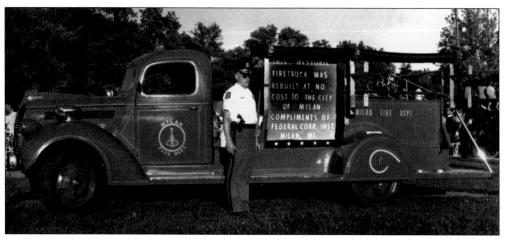

In about 1985, Milan police chief Warren Hale stands proudly in front of the 1938 Ford fire truck. City of Milan officials were about to dispose of it, but they stated the truck could be donated to a nonprofit organization. Hale established the Milan Area Historical Society especially to receive the truck. Then he convinced the local Federal Correctional Institution to restore it at no cost to the city. (Photograph by Paul Holcomb.)

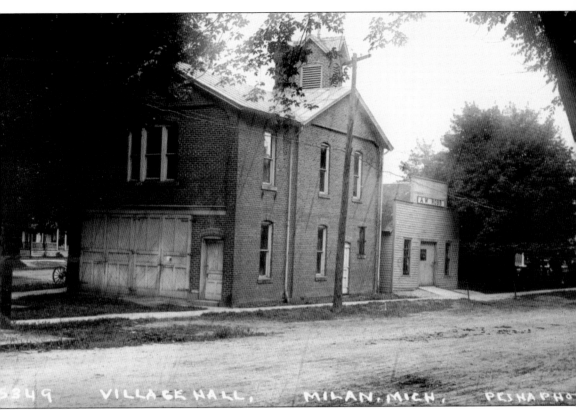

The Milan Village Hall and fire barn are pictured about 1910, when the building was still quite new. The hose-drying tower dominates the roof. This brick building was dedicated in February 1897. The previous fire barn was a wood building in the same place; it was adapted from a carriage shop. Along East Main Street, note the downstairs window on the right—bars on that window indicate a small jail inside. A blacksmith shop owned by Alex Robb is next door, almost close enough to touch the fire barn. (Photograph by Frank Pesha.)

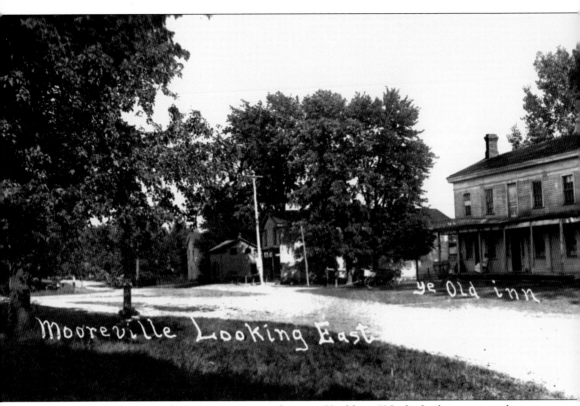

Someone selling postcards wrote a message on this one, "Ye old inn." No doubt the accommodations were plain but comfortable. Mooreville could support a stagecoach hotel. Travelers from Ypsilanti followed a road along the edge of a prehistoric lake, taking them into the heart of Mooreville on the way to Adrian or Jackson.

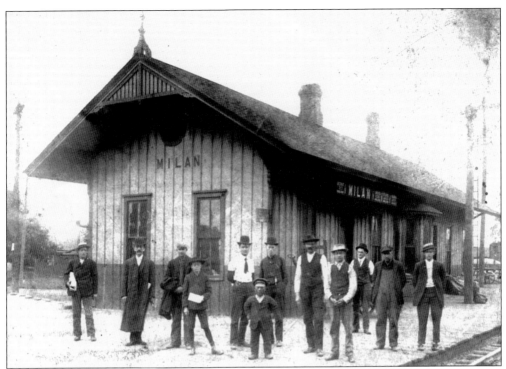

Milan's train station was burned down and replaced more than once. This postcard from about 1905 shows an earlier version of the station, with Victorian details. A distance chart on the side indicates 37 miles to Detroit, 235 miles to Chicago, and 443 miles to St. Louis, Missouri.

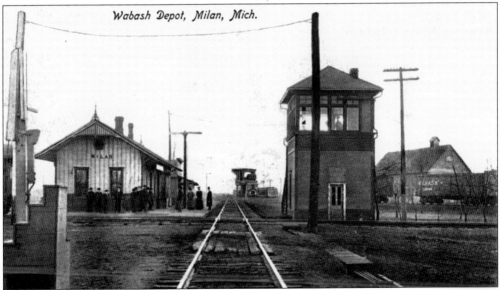

This postcard of Milan was taken between about 1908 and 1912. It is labeled as the Wabash train depot, but it was actually the Union Depot. One building served both the Wabash Railroad and the Toledo, Ann Arbor and North Michigan Railway. This train station was replaced, and only a small section of that building survives to the present. The rest of the structures in this picture are gone, having been burned, torn down, decayed, or hit by trains.

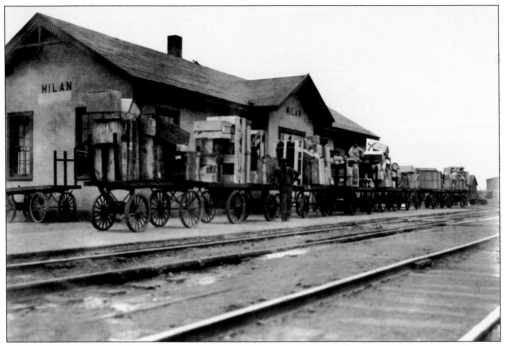

Mail, freight, merchandise, or any other baggage was set out on baggage carts, as seen here in front of the Milan Union Station around 1920. These carts had extra-large wheels with wide rims to get them over the brick pavement and across the railroad tracks. These items are all different shapes and packed in wood, including barrels. Some of the freight may be farm produce.

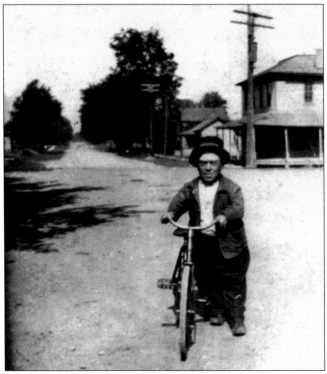

Elmer Beverly may be the most photographed person in the history of Milan. Born a midget in 1870, he considered joining a circus, but his mother talked him out of it. Instead, he went to work for the railroad. Passengers eagerly snapped his picture as he hung out around the railroad station. This picture was taken in front of the Stevens Hotel, near Redman Road and Wabash Street. He was 2 feet, 9 inches tall and is shown here with his specially made bike.

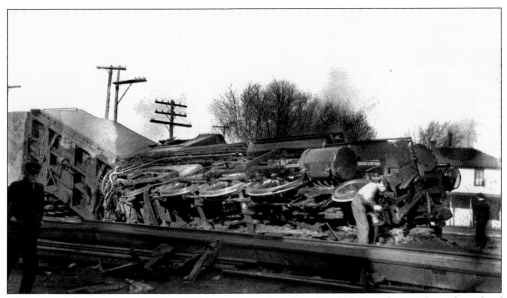

The most delicious train wreck in Milan occurred in October 1934 on the eastbound track of the Wabash Railroad. The locomotive derailed and fell on its side, along with the cars behind it, spilling its precious cargo of chocolate. No one had to worry about cleaning up the mess, as local residents, especially the youngest ones, gleefully rushed in to grab and eat the goodies. Milanites called it the "Great Chocolate Train Wreck."

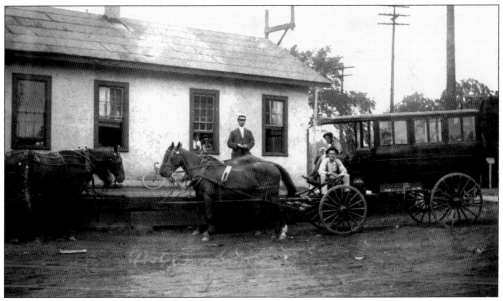

Don Wanty, the station agent, stands on the platform outside the Milan train station while a horse-drawn bus picks up passengers. The driver is Irving "Bony" Jacobs. The photograph was taken about 1910, so Jacobs was 33. The transport service connected train passengers to downtown shops, restaurants, and hotels.

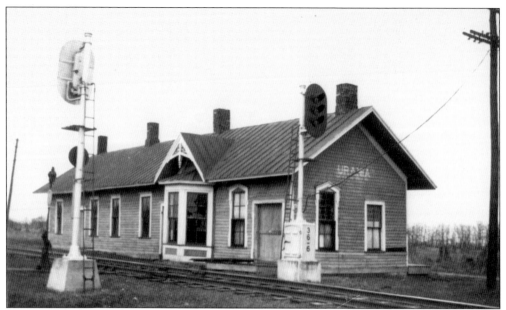

Urania Blakeslee was born in 1831 in Nottingham, England. Her entire family moved to York Township when she was five. She married Thomas Richards in 1848, but Urania died at age 34. Her husband immersed himself in the railroad issue, working hard and spending his money to bring the Ann Arbor Railroad to Milan. Apparently he was rewarded for his efforts; he got the chance to name Urania Station on Willis Road in his late wife's honor.

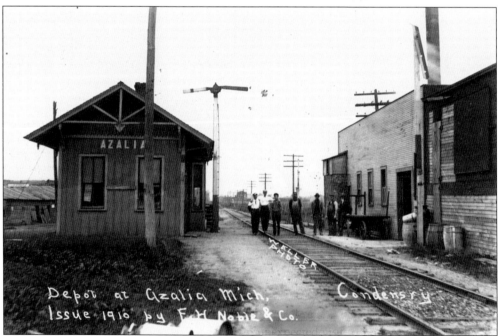

East Milan grew up as a separate community with its own brick downtown and manufacturing facilities. It got the name from being on the east side of Milan Township. When the Ann Arbor Railroad came through in 1878, a conductor named the East Milan station Azalia after his daughter, and the name stuck. This photograph was taken in 1910.

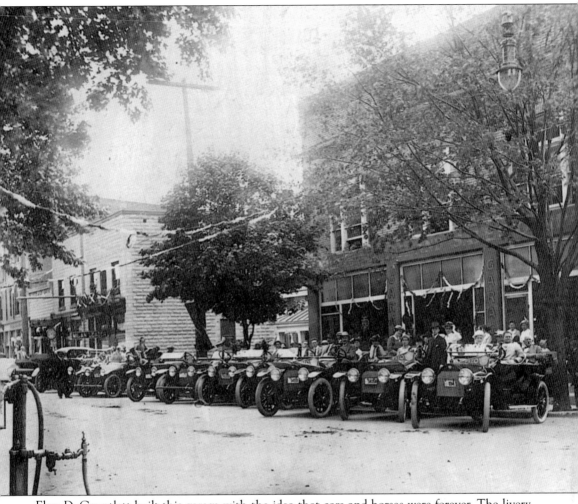

Elon D. Gauntlett built this garage with the idea that cars and horses were forever. The livery was on the ground floor, entered from the back. The main floor accommodated a car dealership. The third floor was fitted for roller-skating. By 1920, this picture shows the cars were going strong, but there is no sign of the four-legged beasts. Notice that these people are dressed to the hilt while seated in the new Reos. That hose in the left foreground is a gasoline pump. (Photograph by George Weller.)

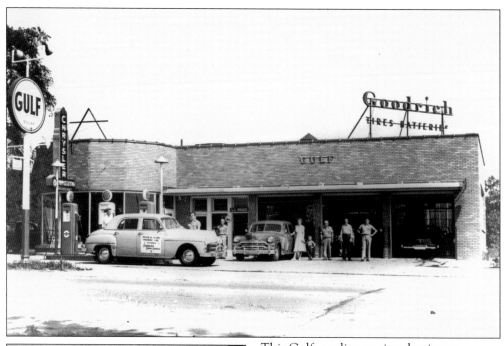

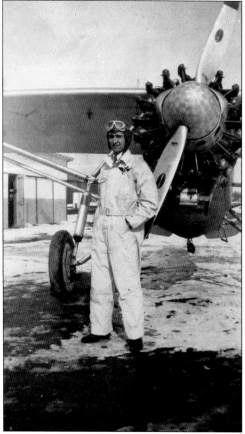

This Gulf gasoline station dominates a Chrysler Plymouth car dealership on Wabash Street in 1949. A bridge over the Saline River used to be located here, but Henry Ford moved the river in 1937, providing solid ground on this spot. From left to right are the owner's son Duane Schultz at the gas pump, Walt Nickell, Boyd Kinsman, Maurine Schultz, Stewart Pretzman, Bill Pretzman, owner Leland "Dutch" Schultz, and Max Buxton. Today this is the Milan Area Fire Department.

Pete Johnston was well known in the Milan area as a dealer in coal and lumber. His retail area was near the Ann Arbor Railroad and Division Street. Later in life, he took up flying as a hobby. This picture looks like it was taken around World War II.

Seven

SCHOOLS AND CHURCHES

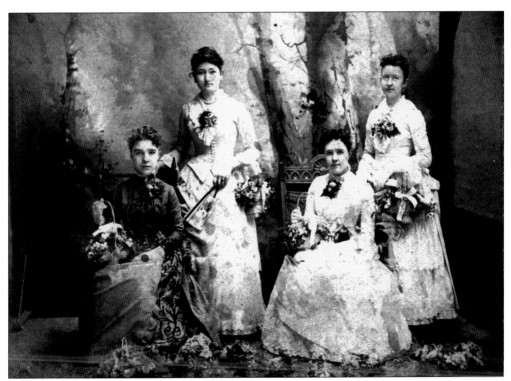

Milan High School's second graduating class poses for a formal portrait in 1886. From left to right are (first row) Gertie Hanson (Babcock) and Anna Delaforce; (second row) Ella Murray (Locke) and Grace Wilson (Butler). It used to be tradition for students to leave school after completing the eighth grade at a one-room country school. Having a high school in Milan was a welcome step up.

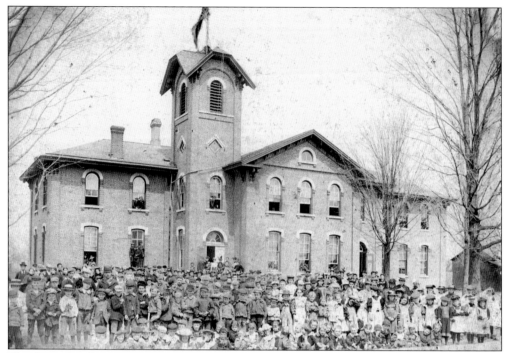

The first schoolhouse in Milan was built about 1854. It was a log structure at 122 East Main Street. In 1862, the school district provided this lovely brick structure on the north side of Hurd Street at Ferman Street. The crowd of scholars in this mass portrait around 1895 shows the school was a bit on the small side by that time. It burned down on January 10, 1900.

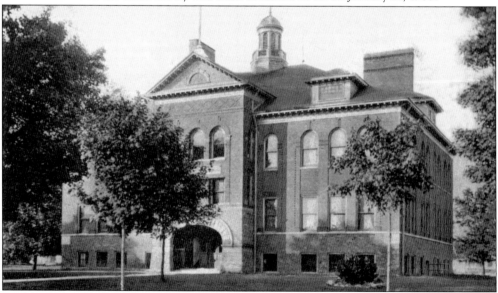

When the first brick schoolhouse burned down in 1900, the Milan School District immediately replaced it with this brick schoolhouse near the same location on Hurd Street. Milan schools offered everything a scholar could want, including Latin, memorized poetry, algebra, and so on. There was no need to travel to Ann Arbor or Ypsilanti for high school. This building was torn down in the late 1970s to make way for housing.

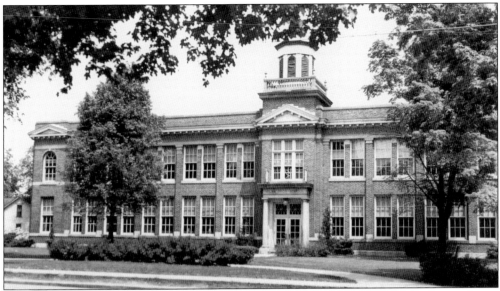

On June 10, 1927, this building was dedicated as an addition to the Milan School, providing a gymnasium that could be used as an auditorium. The school also contained a library, a first-aid room, and classroom space. Milan students completed school here until 1958, when a new high school was dedicated on North Street.

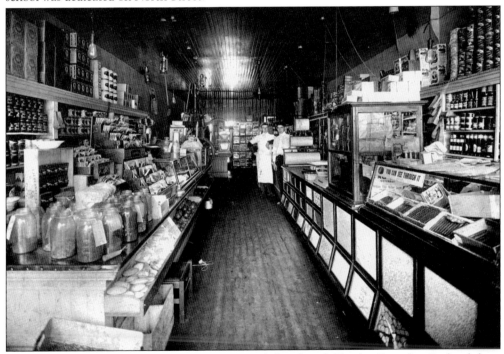

Charles Blancet (left) is in his grocery store with his friend Charles Forsythe. Both of these young men were high school students while operating the Star Grocery Store in 1916. On the left, Jersey brand corn flakes, pork and beans, and seed packets are found. On the right are tobacco products, Old Reliable coffee, and Mother's oats. Pieces of bread and fresh fruit are laid out to tempt shoppers. This store was somewhere in Milan, but the exact place is not known.

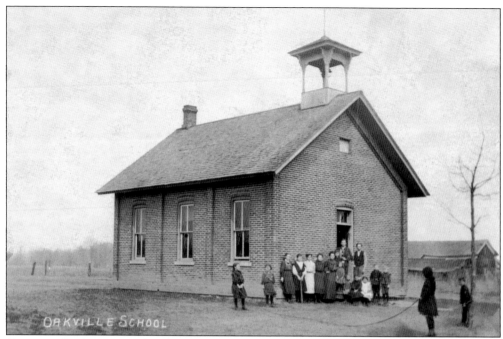

Country schools got started in the 1870s around the Milan area. Each school had its own district. Grades kindergarten through eight were offered, usually in one room. A single teacher gave all the lessons. Oakville School, shown here, was built on the east side of Tuttle Hill Road near Oakville Road. It still stands, being used as a home, minus the school bell.

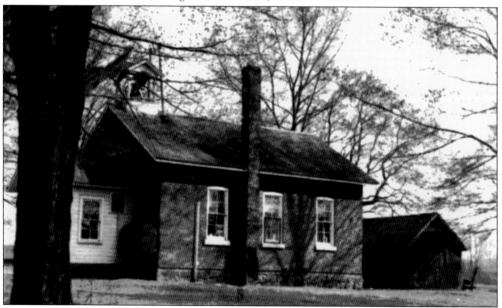

One of the more scenic country schools was the Barnes School along Plank Road in London Township. This photograph, taken in 1951, shows the bell on the roof just behind the tree on the left. The land for this school came from Eliazer Barnes, an influential pioneer in the area. Born in Vermont about 1808, he came to the Milan area to farm, holding many political offices along the way, including a seat in the state legislature.

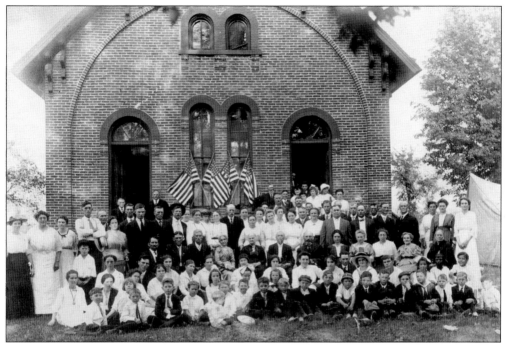

The Fryburg School is especially attractive compared with other rural schools at the time. Built in London Township on the northwest corner of Plank Road and Sherman Road, it was designed as a one-story structure. It is shown here during some kind of celebration, such as a homecoming. Fryburg closed in about 1954 due to consolidation in the Milan Area School District. It serves now as a residence, with a second floor added inside.

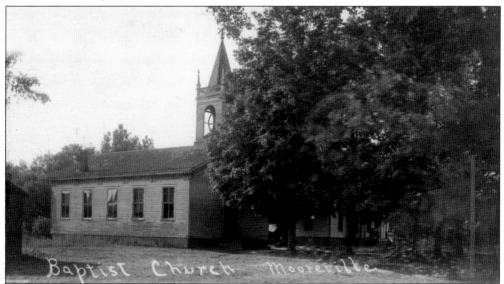

Some members of York Baptist Church asked for letters of dismissal in 1843 to start a new church in Mooreville. The church, shown here, was built around 1848. On the far left is a horse shed that members of the church could use to protect their animals during services. The building served as a church until 1913, when it became a garage. It slowly deteriorated until it finally burned down on April 10, 1994.

The Union Church looks great in a postcard from about 1920. The first church in Milan, it was built in 1866 just west of the downtown. Before that, Thomas Braman had allowed residents to use the third floor of his hotel for worship services. Then he generously let the community put up a church on his land. Five denominations shared the building, scheduling services every other Sunday and at different times. The church looks almost the same today, minus the bell tower.

Here is Marble Memorial United Methodist Church as the building looked when it was first built on East Main Street. The congregation was established in 1840, meeting in members' homes. When the Union Church Society offered a church in 1866, the Methodists participated. In 1887, Hannah Marble gave a piece of real estate to the church, where this building was erected. It was enlarged in 1955.

The Maccabee Hall, as it was known, started out as a Methodist church in Mooreville shortly before the railroads came to Milan. Once the railroads arrived in Milan and bypassed Mooreville, the newly built church fizzled out. Businesses in Mooreville closed one after the other, and residents actually moved their homes to Milan. This church was transformed into a Maccabee Hall, and then it served as the York Township Hall. Today it is a residence.

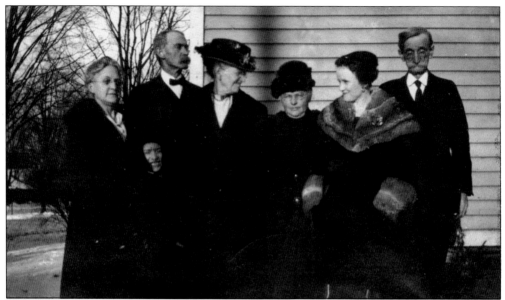

Joel Marble (right) poses for a snapshot with his family around 1921. From left to right are Emma King Dexter, her husband Alva Dexter, unidentified, Marble's wife Florence King Marble, and his daughter Helen Marble Warsaw; the boy in front is Joel's son Lawrence B. Ward. Joel's family was important to Milan—his father, Buckley Marble, was a contractor and justice of the peace, and his mother donated land to build Marble Memorial Methodist Church. Joel established Marble Park Cemetery.

On October 16, 1878, a group of Presbyterian ministers from the surrounding area met for a worship service in the Union Church of Milan, organizing the First Presbyterian Church of Milan. The members dedicated a new building on August 14, 1883, on the west side of North Street just north of Hurd Street. That building, shown here, served the congregation until it was destroyed by fire in the early hours of January 11, 1951. The members quickly built another church on Smith Street, which still stands.

In February 1949, Pastor Eddie C. Wilson was meeting with other African Americans in Milan when they decided to start their own church. Some of the first members lived on Ash Street, and some lived in nearby communities. Pilgrim Rest Baptist Church was born, and soon it had a building at 233 Elm Street. This photograph was probably taken around October 1951, soon after the church was built. The same church continues to worship here.

The Immaculate Conception Catholic Church is being built on North Street in this 1911 image. Catholics had a church in Cone that was built at an earlier date. The Union Church on West Main Street also offered a sanctuary to local Catholics, but the congregation wanted a home of its own in Milan, and this fine building was the result.

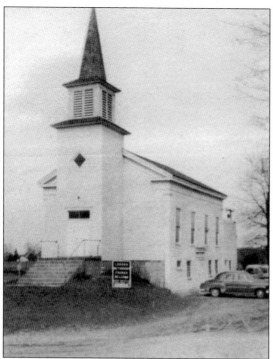

Some residents of London Township organized a Methodist church in 1832, with headquarters in Maumee, Ohio. Preachers came through the circuit, stopping in London Township to hold services. A committee met in 1852 to plan for a meetinghouse. Emma Ingersoll donated property along Plank Road for the church, and it became a reality in 1853.

London Methodist Church along Plank Road has one of the few remaining cemetery vaults in Michigan. This one was used in winter while waiting for spring when the ground thawed sufficiently for burial. Up close, one can still see shelf space inside for up to 10 deceased persons. The London Cemetery probably goes back to the 1850s when the church was built.

Eight

LOCAL FLAVOR

The crooked tree displays its majestic foliage for another glorious summer. Ray Royal's Friendly Mobil service is enjoying the shade in 1944. Milan's landmark tree on the southwest corner of Dexter and County Streets has inspired illustrations, logos, and emblems. Some say a fence rail fell on it when it was a seedling, causing it to bend this way. Others say it is growing where a Native American trail makes a sharp turn, so it was bent by Native Americans as a trail marker.

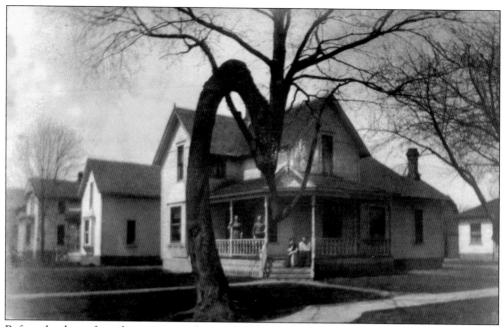

Before the days of gasoline stations, the crooked tree towered over a home. Perhaps the crooked tree grew in that place before homes were built in Milan. These people asked for a photograph of their house, and of course the crooked tree had to be in the picture. Some residents of Milan are trying to grow new crooked trees today; perhaps some lucky family will again have one in its yard.

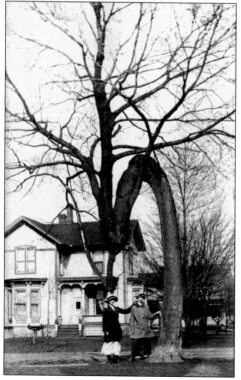

Doris Miller (left) and her sister Maureen Phillips asked someone to snap their picture under the crooked tree around 1910. Behind them, Dexter Street is a dirt road. The Victorian house is no longer there; St. Paul's Lutheran Church stands on that spot. (Courtesy of Millard Phillips.)

A gasoline station owned by Leland L. Schultz enjoyed the famous crooked tree, as shown in this 1939 photograph. However, the tree's life was a struggle. Once enjoying a quiet spot where two dirt roads came together, the crooked tree now endures paved roads. With development, the tree eventually was paved in on all sides. Around February 1960, the poor tree had passed on, so Milan village employees cut it down and threw it in the dump.

A pickup truck drives past the "Welcome to Milan" sign on East Main Street near U.S. Route 23. The sign features the ubiquitous crooked tree; it looks like it has a pretzel in its trunk. The iconic tree appears on stationery for the City of Milan, on water towers, on T-shirts, and on letterhead for the Milan Area Historical Society.

The federal detention farm opened in 1933. From that time until 1939, it included up to 15 female inmates in a separate wing. This photograph shows some of them in a row along a hallway, working on sewing projects. The prison was constructed on the sandy soil of Milan in 1931. Officials picked that location because prisoners could not tunnel their way out through sand. Prisoners did farmwork at the prison, growing much of their own food. The farming was discontinued in 1967 because it was seen as impractical.

Anthony Chebatoris became one of Milan's most notorious criminals after he was convicted of bank robbery. He and a friend visited the Chemical Bank of Midland on September 29, 1937. The outcome was disastrous. According to a federal law, if someone dies during a bank heist, the robber can be executed. He is shown here in October 1937 at the federal courthouse in Bay City, where he was tried and convicted. (Courtesy of Walter P. Reuther Library, Wayne State University.)

Chebatoris was born in Poland in 1900. After a botched bank robbery, he found himself at the federal detention farm in Milan on death row. At dawn on July 8, 1938, he was hanged, the only execution by hanging in Michigan since it became a state. The local funeral home is shown here taking his remains to a hearse for burial at Marble Park Cemetery in Milan. Owner Art Stevens is the pallbearer in back. (Courtesy of Walter P. Reuther Library, Wayne State University)

Prof. Henry C. Friend had a deal with William Cotterill, an investor in sugar stock. Friend could keep his electric sugar-refining machine a secret. Cotterill and the other investors bought stock in the machine, but they never actually saw it. One day, probably in 1885, Friend lifted the cloth and gave Cotterill a glimpse, as reported later in the *New York Times*. After the scandal blew open in 1889, the *New York Times* reported on it almost daily, especially about the Milan residents involved, including Friend's wife, Olive; her mother, Emily Howard; Emily's husband, William Howard; Emily's brother, Lyman Burnham; Burnham's son-in-law, Gus Halstead; and Halstead's brother, George. (Drawing by Grace Albers.)

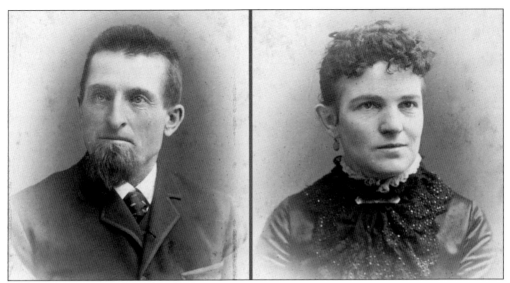

Milan resident William Henry Harrison Hack was known as "uncle Henry" to his niece Olive Friend. He took a few minutes to visit a photography studio in New York close to Friend's home for a quick picture, and he took his wife, Mary Case, along as well. Case was born in Milan in 1842. She followed her sister Emily Burnham Howard to New York for a visit while the Electric Sugar Refining Company scandal was in progress. The Milan gang was busy stealing money from residents of New York, Liverpool, and Birmingham, England, in a stock swindle.

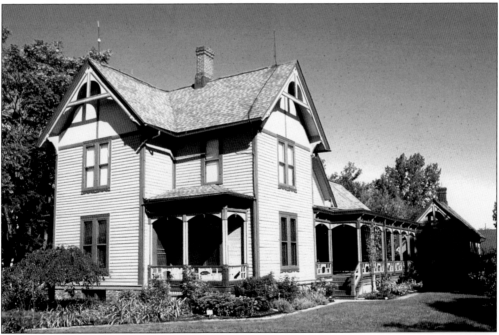

Olive Friend and her young son William moved into this gorgeous Milan home on April 19, 1888. She started construction of the house as a quiet escape from New York, where they had tricked stock investors into paying for a fake sugar refining system. Olive's husband, Prof. Henry C. Friend, never saw his new house. He died of alcoholism on March 10, 1888, just one day before a deadly blizzard hit New York. It is shown here as the present Hack House Museum.

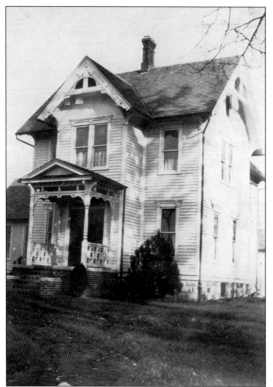

In 1888, Olive Friend's mother Emily Howard had a lovely Victorian home built on her farm east of Platt Road on Arkona Road. Her home was practically identical to her daughter's home on County Road. Both homes applied stick-style Victorian architecture, and both had three-seat outhouses. Eventually she gave up this farm to her attorneys as her husband was entering prison for the sugar scandal.

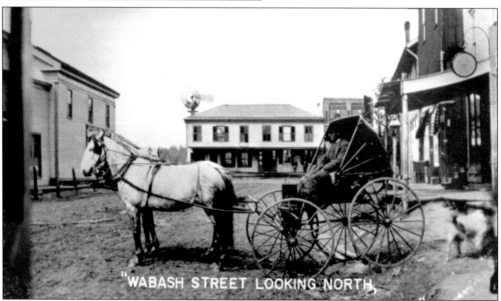

"WABASH STREET LOOKING NORTH,

William Howard is seen in 1895 seated in a horse-drawn carriage. The Babcock Hotel is behind him. Howard was celebrating his release from prison in New York after the stock scandal. He and his wife, Emily Burnham, cooked up the scheme along with Emily's daughter Olive Friend and her husband, Henry Friend. The Milan gang told New Yorkers to invest in Henry's electric sugar-refining machine. The machine was kept a deep, dark secret. Investors placed their life savings in electric sugar stock, hoping to make a killing.

Walter F. Stimpson was born in 1870 on a farm west of Mooreville. In 1892, at the age of 22, he paused from his work as a teacher and looked closely at a grocer's scale. He headed for the blacksmith tools in a barn at his father's farm and hammered on a piece of metal, creating a computing scale. This scale was different, even revolutionary. A grocer could check the weight and see the price automatically. Stimpson received 74 patents during his lifetime, mostly for scales.

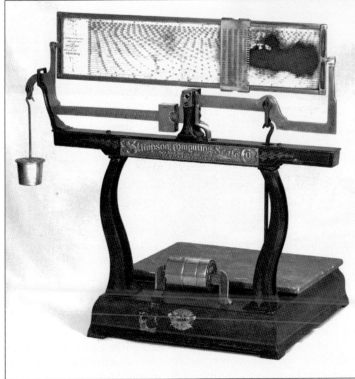

Stimpson probably manufactured his first few computing scales in Milan behind his mother's home at 104 East Main Street. His parents retired from the farm and moved to Milan. With help from Mell Barnes, the local banker, he set up a manufacturing facility in Tecumseh and then in Elkhart, Indiana, where this scale was made. The rectangular computing table along the top contains markings to indicate both the weight and the price. This was a huge benefit to merchants.

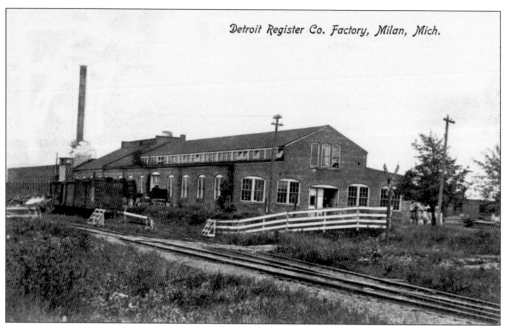

Detroit Register Co. Factory, Milan, Mich.

The partnership with Mell Barnes did not work out for Walter F. Stimpson. While Barnes was serving as secretary at the Elkhart plant, he quit sending the royalties back to Stimpson. After a long lawsuit in federal court, Stimpson stayed in the action by manufacturing his scale products in Detroit and also by building a foundry in Milan around1902. In 1906, he moved to Northville and sold his Milan plant to the Detroit Register Company.

While manufacturing scales at the factory in Milan, Stimpson concentrated on the jumbo-sized farm scales. His products were suitable for weighing a sack of corn, a hog, or a wagon full of pumpkins. He made scales like this in Milan from 1902 to 1906. The one shown here belongs to collector Greg Moss. During his farm scale production in Milan, Stimpson paused on February 5, 1905, to marry Estelle Heyn of Toledo.

124

Just as he was setting up his farm-size scale plant in Milan, Stimpson decided to build a three-story hotel in the middle of downtown Milan. On January 12, 1901, Stimpson purchased a piece of land on West Main Street. The main floor, up a few steps from the sidewalk, was entered through a dramatic portico stretching out over the sidewalk. A staircase led up to the 10 hotel rooms. The lower level held restaurants, or a mini-mall. The hotel still stands, minus the portico.

Stimpson produced his first scales in Milan. Then he spread out and moved to various cities in the Midwest. He occupied two floors of this manufacturing facility in Louisville, Kentucky. In 1930, Stimpson built a larger, more modern plant in that same city. One of his Detroit companies merged with a timepiece company and a cash register company and then changed its name to International Business Machines, or IBM. Stimpson died in 1942 in Louisville.

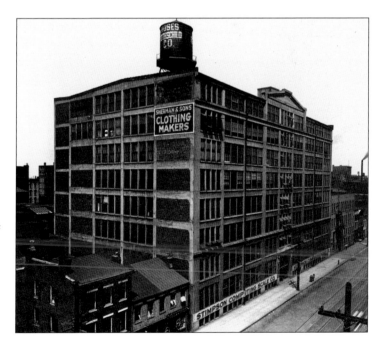

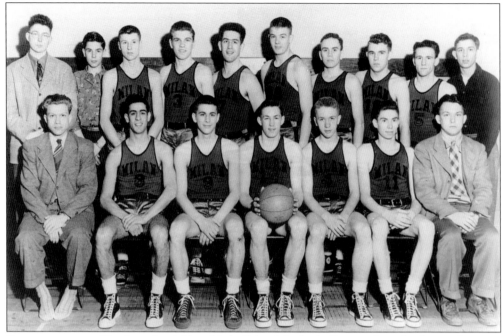

Everyone went wild when the Milan High School basketball team brought home the state championship in 1948. Front row, left to right; Ron Sukup, coach; Al Bassett, Sherman Collins, Allen Benjamin, Roland Dunsmore, Carl Tschirhart, and Ron Shadford, assistant coach. Back row: Lawrence Richards, manager; J. C. VanOrman, Wayne Tooman, Roger Sanford, Richard Trim, Harlan Benjamin, David DeTar, John Taylor, "Corky" Holmes, and Dean Lidgard, manager. (Photograph by Paul Holcomb.)

Ethal Richards administers the oath of office to Millard Phillips on November 13, 1967. After almost a century as a village, it was time for Milan to go forward as a city, with Phillips elected as the first mayor. Local civic leaders had formed a commission to prepare a city charter. Civic groups had worked hard to knock on doors, pass out leaflets, and buy advertisements to pass the charter. It was another step forward for Milan's history.

BIBLIOGRAPHY

Beakes, Samuel. *Past and Present of Washtenaw County, Michigan.* Chicago: S. J. Clarke Publishing Company, 1906.

Combination Atlas Map of Washtenaw. Chicago: Everts and Stewart, 1874.

County Atlas of Monroe, Michigan. New York: F. W. Beers, 1876.

Delaforce, Ann E. "History of Milan." Essay presented to the Woman's Club. Milan, MI: May 9, 1939.

Dunbar, Willis F. and George S. May. *Michigan, A History of the Wolverine State*, 3rd edition. Grand Rapids, MI: William B. Eerdmans Publishing Company, 1995.

Fuller, James Harland with aid of younger relatives. Memorandum of Milan and York Township area in 1833 as part of Dexter and Fuller family influx. 1901.

Hinsdale, Dr. Wilbert B. *The Indians of Washtenaw County, Michigan.* Ann Arbor, MI: George Wahr, 1927.

History of Washtenaw County, Michigan. Chicago: Chas. C. Chapman and Company, 1881.

Portrait and Biographical Album of Washtenaw County, Michigan. Chicago: Biographical Publishing Company, 1891

Schwartz, James Z. "Taming the 'Savagery' of Michigan's Indians." *Michigan Historical Review*, Vol. 34, No. 2, Fall 2008.

Standard Atlas of Washtenaw County, Michigan. Chicago: George A. Ogle and Company, 1985.

Squires, Arleigh, ed. *Ancient and Modern Milan.* Milan, MI: Milan Area Historical Society, 1976.

Wing, Talcott Enoch, ed. *History of Monroe County, Michigan.* New York: Munsell and Company, 1890.

www.arcadiapublishing.com

Discover books about the town where you grew up, the cities where your friends and families live, the town where your parents met, or even that retirement spot you've been dreaming about. Our Web site provides history lovers with exclusive deals, advanced notification about new titles, e-mail alerts of author events, and much more.

Find *Your* Place in History.